SOUTH STAFFORDSHIRE COALFIELD

NIGEL CHAPMAN

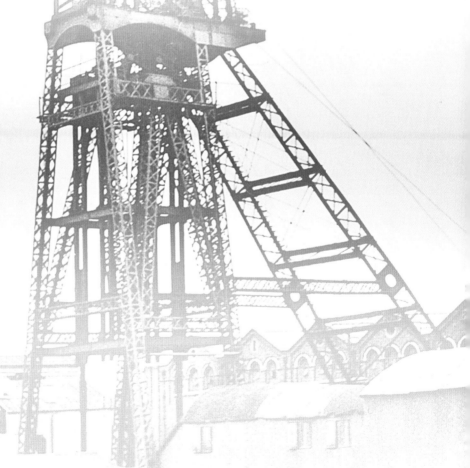

AMBERLEY

First published 2011

Amberley Publishing
The Hill, Stroud
Gloucestershire, GL5 4PE

www.amberley-books.com

Copyright © Nigel Chapman, 2011

The right of Nigel Chapman to be identified as the
Author of this work has been asserted in accordance
with the Copyrights, Designs and Patents Act 1988.

ISBN 978 1 84868 971 8

British Library Cataloguing in Publication Data.
A catalogue record for this book is available from
the British Library.

Typeset in 9.5pt on 12pt Celeste.
Typesetting by Amberley Publishing.
Printed in the UK.

INTRODUCTION

Reading some of the descriptions of the Black Country in the nineteenth century, one could be forgiven for believing this stood at the gates of Hell. Much was made of burning heaps of coal and coke, with mining waste burying agricultural land and slag tips at the furnaces glowing red. The noise of hammers and machinery filled the air. Gradually, these industries have been replaced with warehouses and retail parks. These much quieter and cleaner industries have changed the landscape beyond all recognition along with the spread of housing over the West Midlands. Some twenty to thirty years ago it was possible to find odd corners of the Black Country that reminded one of the mining past. Most of these scenes have now gone, often replaced by housing and land reclamation schemes. However, in some locations, such as New Hawne, Warrens Hall and Himley Woods, something of the old Black Country remains, but without the blackness of colliery waste tips; most of which is now hidden under a carpet of greenery. We have, over the last century, lost an amazing amount of our industrial heritage to light industry and housing. I wonder how much of this will survive the next 100 years? Over the years, photographs and drawings have been made of the area's mining remains to form a record of what once existed.

Nigel A. Chapman

THE SOUTH STAFFORDSHIRE COALFIELD

Stretching in an unbroken line for over fifteen miles, from Stourbridge in the south to Brereton in the north, the middle coal measures of the Carboniferous series formed the South Staffordshire coalfield. Areas of coal measures were also to be found in the neighbouring county of Worcestershire, giving rise to the nineteenth-century title of the South Staffordshire and East Worcestershire Coalfield. The exposed and therefore easily worked portion of the coalfield was found at depths of 30 to 180 metres below the surface in the shape of a rough triangle with the apex in the vicinity of Brereton, widening out towards Essington in the south-east and to Pelsall in the south-west. This portion of the coal measures, usually referred to as the Cannock Chase coalfield, was separated from the Black Country field by a major fault running east and west near Bentley. The Bentley fault is recorded as having a down-throw of over 100 metres, causing the break-up of the thinning thick coal seam of the Black Country into around fifteen thin seams while pushing the coal measures deeper underground. The Cannock field had a number of large faults in the strata, cutting the seams into separate areas, raising some towards the surface and taking other areas deeper underground than in the Black Country proper. On Cannock Chase, large areas of shallow coal was mined form the sixteenth century onwards, leaving much broken ground still visible today. While not far away, in mines such as Cannock Wood, the shafts had to be sunk over 100 metres to access these seams. The greater depths required a considerable outlay in capital creating shafts, erecting plant and buildings so larger royalties of coal seams were leased to make these collieries viable. The increased depths also meant that until the nineteenth-century technology in terms of steam-pumping engines were not available, so the Cannock field was not fully developed until the mid-nineteenth century.

Early coal mining was to develop in the areas of Essington, Pelsall, Brownhills, Great Wyrley and Brereton to work the shallow seams of coal, while the discovery of deeper seams was to witness the development of major collieries in the nineteenth century. Part of this development was assisted by the construction of a complex system of railways with links south to the markets of London for the sale of Cannock coal. By the mid-nineteenth century, these links to distant markets were to bring about the greatest expansion of mining the area would see. One of the pioneers of this expansion was John R. McLean, an engineer surveying for the proposed railways. He noted the possibilities of the area and leased the Hammerwich Colliery in 1854. From this beginning rose the Cannock Chase Colliery Company, who went on to operate ten large collieries on the Chase and supplied the example that others quickly followed.

South of the Bentley fault, several thin coal seams came together in the Dudley to Oldbury area to form the famed Thick or Ten Yard coal of about 8 metres thick. The thickest coal seam found in this country, at the shallow depth of about 100 metres, this seam was much

exploited across the coalfield. It supplied coal for the house fire and the various iron and later steel industries and was the foundation of the many small metal trades of the area. It also supplied steam coal for the multitude of steam engines driving machinery and collieries across the West Midlands. Said to have been black during the day from the smoke of all these manufactures and red at night from the fires of the blast furnaces, this was the area known as THE BLACK COUNTRY. It is said that this coalfield supplied about 5 per cent of the coal produced in this country during the late nineteenth century. This was to be the high point of the area, as the supply of coal was exhausted, and the pits gradually closed, leaving huge area of derelict land often buried under mounds of waste shale.

The mid-twentieth century was to see major reclamation schemes carried out across the coalfield to return land not to agriculture but to provide housing for the expanding population. Because of this destruction of all things relating to the mining past, much has been lost and very few traces of this heritage remains. It has become very easy to go out to the site of a major colliery complex or ironworks, to actually be standing in a council housing estate of mid-twentieth century semis with neat gardens! Fortunately, in a few locations mining remains can still be found, but these are being slowly replaced by the modern world. Of our Black Country mining remains, the most important are the buildings, tips and railway system left at the New Hawne Colliery near Halesowen, Worcestershire. Second are the pump house and chimney with adjacent pit mounds of the Cobbs or Windmill End Colliery No. 3 pit near Rowley Regis, Staffordshire. While on Cannock Chase, the museum of the area is housed in some of the buildings remaining from the Valley Colliery.

COAL MINING IN THE BLACK COUNTRY

No book about mining should disregard the inbye (underground) side of the subject. Without the necessary holes in the ground, a Colliery, mine or pit doesn't exist, therefore I make no apologises for commencing with the most important part of any mining scene.

Having the thickest bed of coal in the country to work at a shallow depth appears to have lead to the development of a wasteful and in many respects dangerous method of working. A man who had saved a few pounds could take a charter from a landlord with coal under his estate and sink a couple of 2-metre-diameter shafts to work the coal. A steam-driven beam engine would wind the coal often on a flat wagon from the shafts to be shovelled into carts waiting at the Pit Top.

Because of the fear of the coal catching fire, as the Thick Coal was prone to, the two gate-roads (roadways) from the shaft bottom were made small to reduce the air flow underground. Then levels were driven off the gate-roads into the coal to develop the 'sides of work'. These were huge areas up to a hectare from which the coal would be removed, in effect becoming an underground quarry. To support the roof, pillars of coal were left called 'men of war'. Commencing at the base of the seam, the coal was gradually extracted upwards until a height of about 8 metres was achieved. To reach these heights the Pikeman would stand on heaps of coal until ladders and planks were required. Should the roof coal decide to fall, he was expected to rush down the ladders and get out of harm's way. The Mine's Inspectorate reports and local graveyards are full of colliers who were hit by falls of coal. Having extracted the coal, the side of work was sealed up and abandoned for several years until it was decided to rework it. Known as 'Thick Coal Pickings', any loose or fallen coal was loaded up and taken away. Sometimes a third reworking was done, and after that, with little left to extract the working was abandoned. Developed in the Black Country, this method of working the Thick or Ten Yard coal seam was unique to the area around Dudley to Oldbury where the thickest part of the seam was located. Other, thinner seams over the coalfield were worked by a system called 'Longwall', where two parallel levels were driven to the boundary of the area (royalty) available to work, a level was driven between the two levels and the coal worked backwards and forwards towards the shafts. Where possible, the timber was taken out and the roof allowed to collapse behind the coal face. Should water appear in the workings, attempts would have been made to lead this back to the shafts and into a sump below the shaft. To remove small quantities of water from the mine, a tank would take the place of a wagon in the cage and be lowered into the water. Raised to the surface, the water would have been delivered to the nearest stream. If the water increased beyond the power of this simple method of removal, either the colliery closed or some form of pump driven by the steam engine would have been employed.

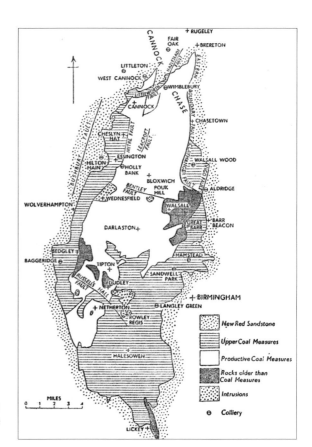

The extent of the South Staffordshire coalfield, with major towns and some of the major faults shown.

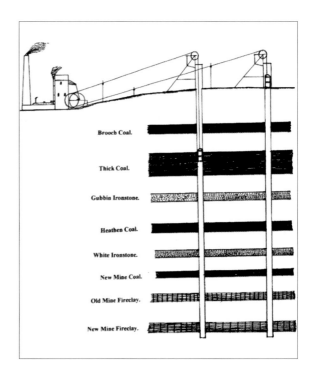

A simplified drawing of Black Country strata showing the various coal and ironstone seams. The combination of coal and ironstone seams within a few metres of each other was to be the foundation of the Black Country industries. In the Halesowen to Stourbridge area, several seams of fireclay were important in the development of a brick-making industry.

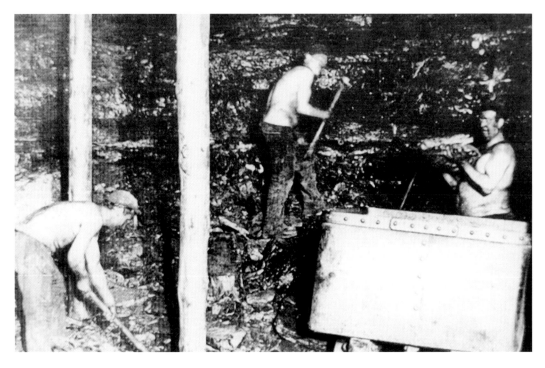

Working in the bottom layers of the Thick Coal, these colliers are pulling down loose coal and loading it into the tub.

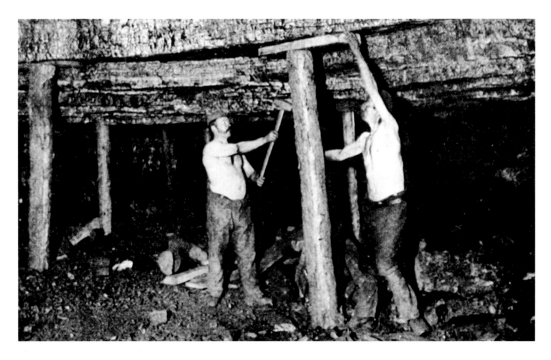

Two colliers in a wide working are setting a prop, usually known as a 'tree'. The miner on the right is holding a lid to ease the prop into place.

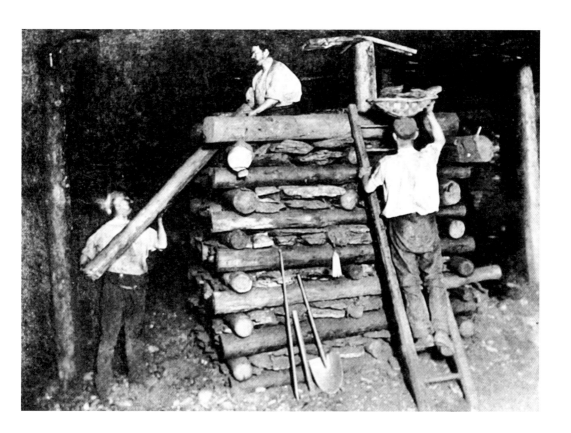

Above: Three colliers are building a cog with horizontal timbers and waste shale. These towers were designed to take the heavy weight of the roof slowly collapsing.

Below: Setting a prop in a typical side of work. The Thick Coal seam was also known as the Ten Yard Coal because of its unprecedented thickness. It was the largest coal seam to be found in the country.

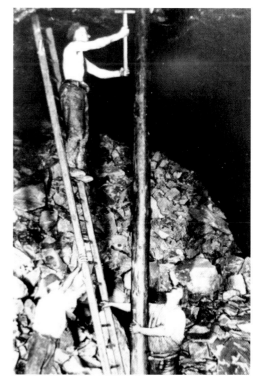

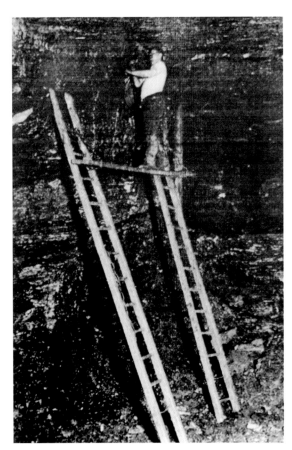

Left: A top 'Cutter', as the most experienced colliers were known, is shown working in the roof of the Thick Coal seam. He would cut the layers of coal, hoping that when they fell it was away from him. Should the coal drop in the wrong direction, he hoped to be able to get down the ladders and out of harm's way. Falls of coal were the most common cause of deaths in the South Staffordshire collieries

Below: A drawing of a typical side of work in a Thick Coal pit in the nineteenth century. On the left, Pikemen are cutting the coal in large lumps for transport on the skip or flat wagon being lead by the boy. On the skip, hoops of iron are seen ready to be used to hold the lumps of coal on the skip for the journey up the shaft. On the right a skip loaded with lumps of coal is seen travelling up the shaft, while the Hooker On watches in the pit bottom. Near the shaft a pillar of coal known as a 'man of war' supports the roof and serves as a convenient lighting post.

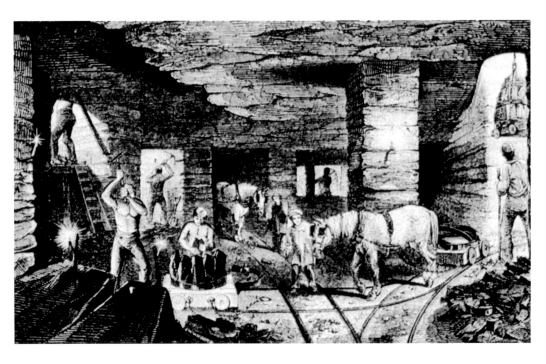

OLDBURY

Coal mining appears to have been carried on at the Brades Works before 1800 to supply fuel for the iron and steel works of Messrs Hunt. A major impetus was given to the development of mining by the construction of the Birmingham Canal, opened for traffic in 1772. A branch canal was constructed in a southerly direction to form the Titford Pool, soon to be surrounded by collieries, often with short tramways to deliver coal to the barges on the canal. Much of the coal was dispatched towards Birmingham, but with ironworks erected along the canal banks for ease of transport of their goods, coal and ironstone was delivered to the works often from the ironworks company's own mines. Most of the best coal had been worked out by the 1860s, followed by the slow contraction of the industry until, by 1900, only a few collieries remained open. These suffered from the inflow of water running down from the Tipton area's abandoned mines. Many attempts were made to organise the pumping of water over large areas, but a lack of co-operation and finance lead to a total collapse of mining by the 1920s.

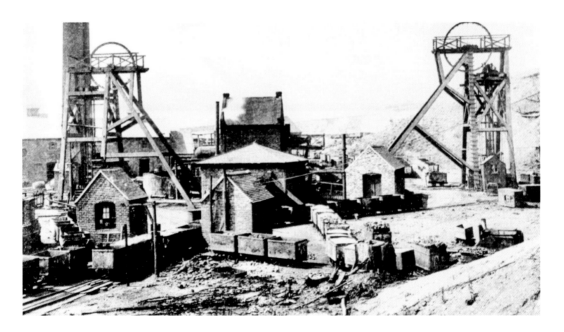

Sunk in 1856, the Rowley Hall Colliery was to produce coal until abandoned as exhausted in 1918. Between the two wooden head frames, towering over the shafts, stands the brick winding house with a steam-driven beam engine inside. The beam can be seen projecting from the right hand of the house. The pit yard is well stocked with tubs; those on the left are empty and ready to go underground, while others in the centre of the picture are waiting to be sent down the incline to the canal basin for tipping into barges.

The empty area in the foreground was the site of the Rowley Hall Colliery and probably contains the filled-in shafts of the mine. When possible, the shaft sites are left clear of buildings but this was not the case during the nineteenth century when it was normal to put timber across the shafts and fill with coal waste. Eventually, the timber failed and the shaft opened up. During the 1970s, a shaft of the closed Grace Mary Colliery under the Birmingham New Road near Round's Green opened and had to be filled with concrete and fly ash. This has sealed the shaft permitting the heavy volumes of traffic to continue using the road.

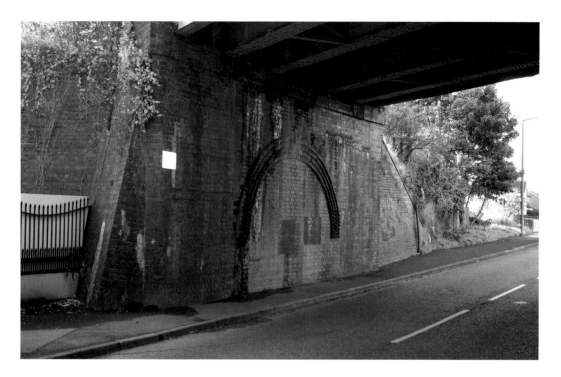

A bricked-up tramway arch under the railway bridge in Penncricket Lane. The tramway existed before the railway was constructed, so the GWR had to provide a bridge over the line.

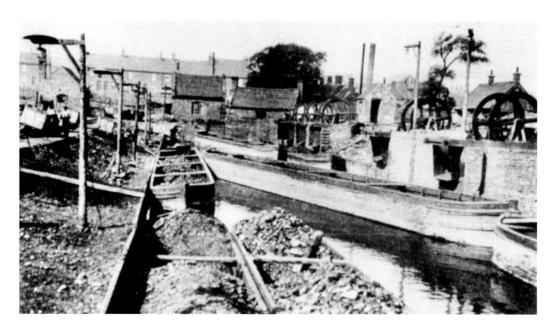

Rowley Hall canal basin around 1900. Coal in tubs from the local collieries was tipped into bunkers to await the canal barges. A busy scene on the edge of Titford Pool: much of the ease of transport of coal and ironstone about the area was as a result of the development of the canal system.

Titford Pool – once a large canal feeder reservoir. During the 1860s, this was a major transhipping point from surrounding collieries. Up to ten collieries fed tubs of coal along tramways to this pool. Now it is a fishing and walking place, with the traffic on the M5 thundering passed.

HALESOWEN

From the medieval period and possibly earlier, up until the 1920s, coal was mined from shallow workings in the Coombs Wood area along the sides of Micklows Hill. Deep mining was developed from the early 1840s by the Attwood family of bankers, with the sinking of the Old Hawne Colliery. Samuel Dawes sank the Manor Lane shafts in 1864, followed by the New British Iron Co. sinking the New Hawne Colliery in 1865. The Witley colliery was to follow in 1872, with Oldnall in 1873. Fireclay was also worked from some of these mines for the brick-making trades. After 1900, the increasing water problems were to slowly drown the workings. The only new venture was the sinking of the Coombes Wood Colliery 1908–1910 by B. Hingley & Co. Most of the remaining collieries were to close during the General Strike of 1921 and stayed closed. Coombes Wood continued working until 1948, while the Beech Tree Colliery lasted under the National Coal Board until 1958.

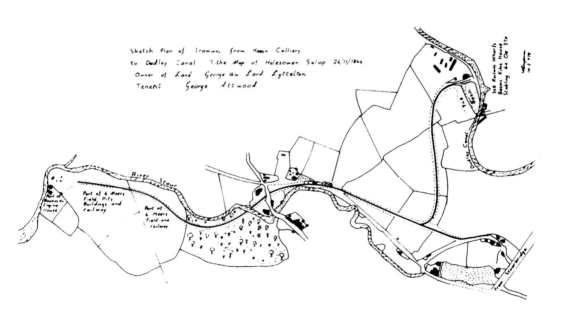

The Hawne Colliery is shown on the Tithe Map of 1844 with a tramway to the Dudley No. 2 canal. This was the first deep colliery in the parish with what was probably the first railway. Coal in horse-drawn wagons was delivered to the Halesowen Docks for transport to Birmingham.

Remaining from the 1844 tramway, this much-altered bridge, now used for road traffic, still spans the river Stour at Hayseech.

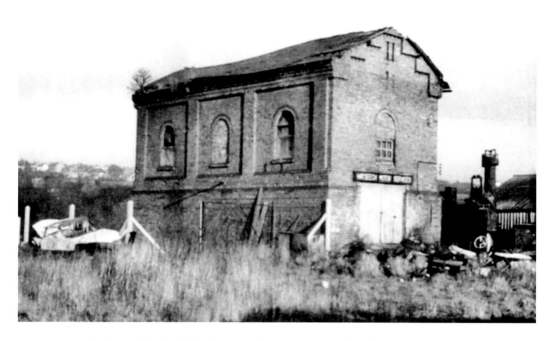

Hawne Colliery. This brick-built engine house was used by the Hawne Mines Drainage Co. to drain the mines until 1920. It was later used as a garage, and was to be demolished in the 1970s.

Halesowen Docks, the terminus of the Old Hawne tramway, has become a marina for narrow boats and still retains a brick canal bridge over the entrance.

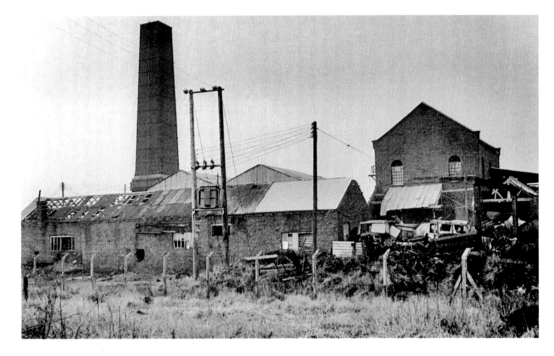

Sunk 1908–1910 to supply the Oldhill and other furnaces with coal, the Coombs Wood Colliery lasted until 1948. The buildings were converted to metal processing before being demolished in the 1960s.

Coombs Wood Colliery, 2010. Later, the waste tip was bulldozed and a factory unit erected on top. The extent of the tip can be seen. It was said that one third of the coal drawn to surface was waste, and after processing would be sent to the tips.

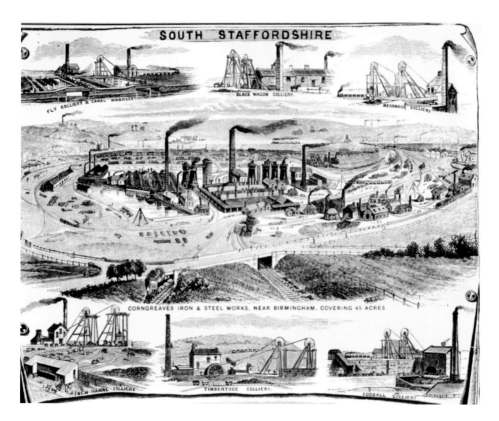

A drawing from a trade publication of around 1880, showing the New British Iron Company's works and collieries at Corngreaves Staffordshire. Developed from a small ironworks operated by the Attwood family, Corngreaves rose to be one of the leading South Staffordshire iron and steel plants. The company went into liquidation in 1894 while the ironworks lasted until closure in 1912.

Corngreaves Ironworks. Much of the ironworks site is now under warehouses as part of a large industrial estate. One or two brick buildings have survived; here is an interesting building formerly part of the brick works.

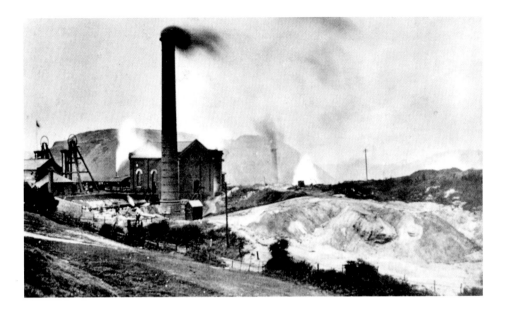

The New Hawne Colliery was sunk in 1864 by the New British Iron Company to supply fuel to their Corngreaves ironworks. Working until the Miners Strike of 1921, the colliery flooded and never reopened. At a later date the buildings were taken over by the council as a supply depot and preserved. They constitute the most complete group of mining buildings left in the Black Country. Sunk to a depth of 268 yards, the colliery produced 400 tons of coal per day. After cleaning, the coal was transported by rope haulage over a viaduct across the River Stour to the Corngreaves Ironworks.

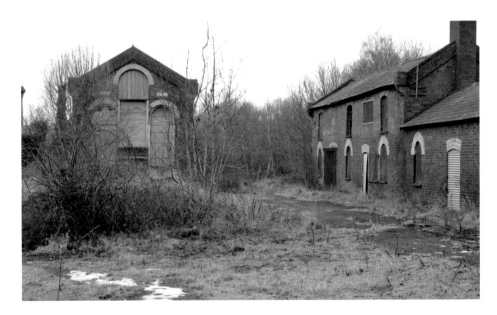

New Hawne Colliery with the winding house on the left, two-storey stores and offices on the right. After the colliery closed, the land and buildings became a council yard, providing protection from vandalism. Not much altered over the years, the buildings are still very much part of a nineteenth century colliery.

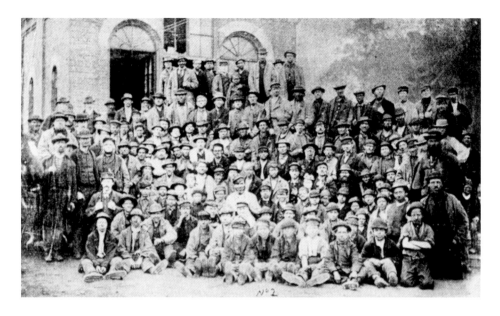

New Hawne Colliery with the workforce outside the front of the winding house around 1870. The Thick Coal seam at New Hawne had a shale band in the middle so the coal was cleaned on a picking belt. Picking provided work for the old or infirm and the young colliers, which would account for the children in the picture.

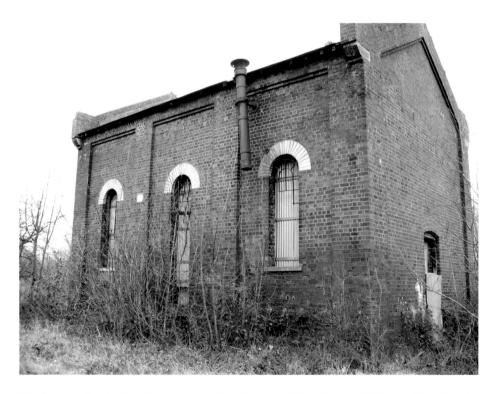

The brick-built winding house erected in 1864 at the New Hawne Colliery still retains the iron pipe of the steam exhaust from the winding engine.

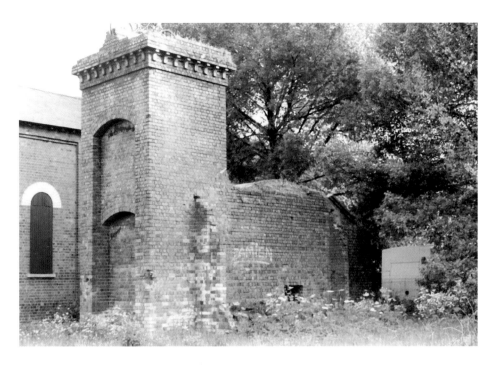

Among the buildings at New Hawne Colliery is the most complete example of a Guibal mine ventilating fanhouse in the Midlands. Probably erected about 1875, this Guibal fan was one of very few ventilators used in Black Country mining.

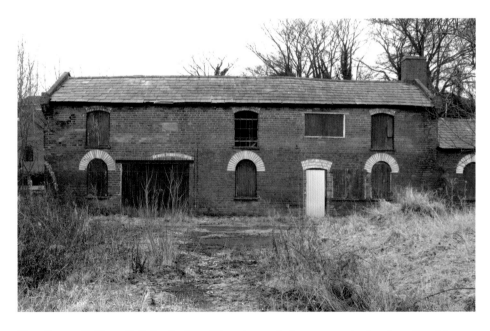

New Hawne Colliery. Built in the late 1860s, the workshops comprised a six-stall stables, an office, two hovels, a blacksmith's shop and a general stores. In 1895, Shelagh Garrett & Co. put a second storey on the stables to provide more office space. The manager at the time was W. H. Chapman, with his brother John as under-manager.

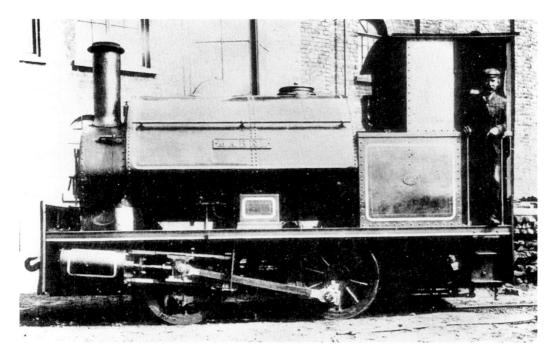

The New British Iron Company operated an extensive metre-gauge railway, linking the ironworks with their collieries and the canal. They were at the time the only ironworks not directly situated on a canal. The loco is *Mabel,* an 0-4-0 tank locomotive built by Bagnall's of Stafford in 1899.

One of the few sections of railway embankment left from the metre-gauge line is seen as it crosses the golf course near the River Stour heading for the New Hawne Colliery.

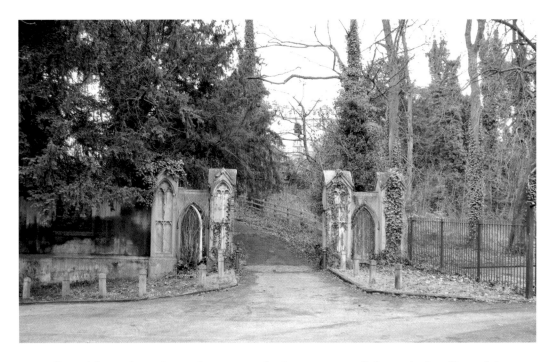

Gate pillars of the Gothic style stand as entry to the Corngreaves Hall, formerly the offices of the New British Iron Company.

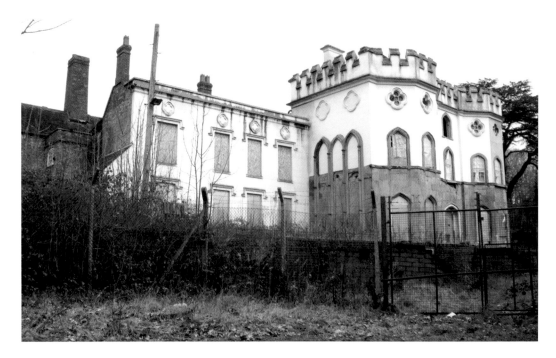

Corngreaves Hall, once the offices of the New British Iron Company, was to be converted into a community centre in the 1970s, and renovated by a Manpower Services team. But the scheme was never finished, leaving the hall derelict and suffering from vandalism. (2010)

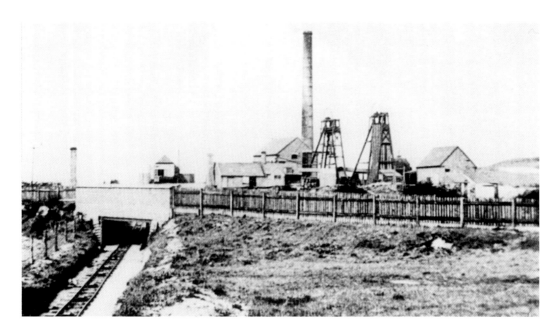

Oldnall Colliery was sunk to a depth of 191 yards in 1874 by James Fisher to work the Thick coal and fireclays belonging to the Oldswinford Hospital. Closed in 1887, the colliery was reopened in 1889 by Messrs Mobberley & Perry to supply fireclay to their brick-making operations. The coal produced was used to burn the bricks. During 1919, a tramway – shown on the left – was constructed for the nearby Beech Tree Colliery to send its output down an incline to their Hayes Works. Oldnall Colliery closed in 1944.

Oldnall Colliery site today is a wasteland of scrub trees and a tip of pit waste. The narrow gauge tramway system has been returned to agriculture except near the Beech Tree Colliery, where a cutting can be found in the woodland.

The remains of a brick-built bridge can be found down the hillside towards the Hayes at the Oldnall Colliery site. Built as a farm access bridge, it is now the only structure of the colliery left.

The major remains at Oldnall Colliery are the track of the incline down the hill to the Hayes. Once used to transport coal and fireclay from the colliery and also the output of the Beech Tree Colliery to brickworks at the Hayes.

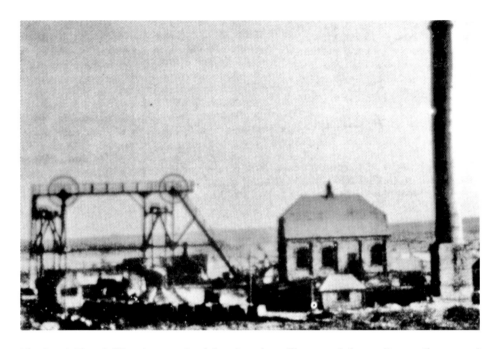

The Beech Tree Colliery in 1931. Sunk by 1874, the colliery was left standing until reopened by Messrs Mobberley & Perry in 1919. They were to extract fireclay as well as the coal seams to supply their brickworks at the Hayes.

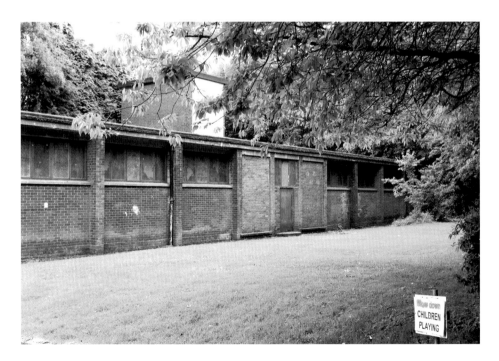

At the Beech Tree Colliery, the major remains today are the baths built around 1950 as part of a modernisation scheme by the National Coal Board. The Scout Movement who took over the building have kept it much as it was in 1958 when the colliery closed.

Across the road is the Beech Tree Colliery waste tip, now clothed in tall trees. The tips have become a nature reserve, while in many places the coal waste can still be found pointing to the origins of the mounds. To the west is the cutting of the tramway system to Oldnall.

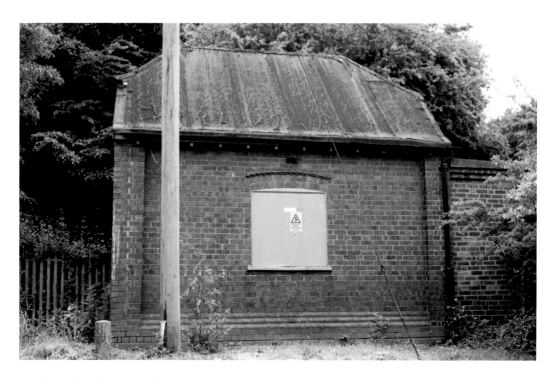

An electrical substation at the Beech Tree Colliery site. Having served the colliery until its closure in 1958, it is now used to supply power to the new housing estates.

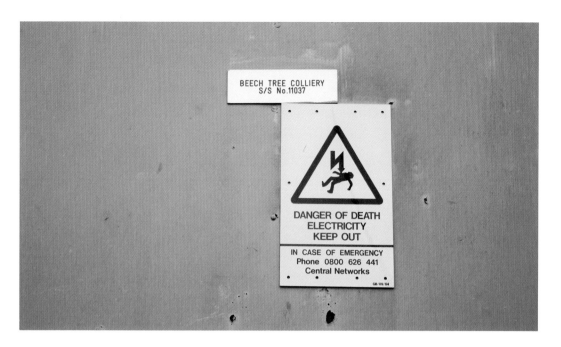

Much to the author's amusement, the plate on the substation still refers to it as Beech Tree Colliery, over fifty years after its closure.

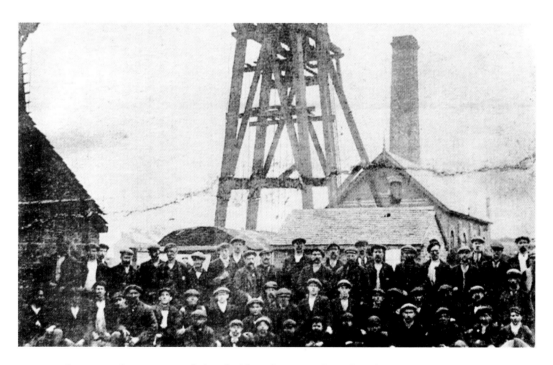

Sunk in 1872 by a group of shareholders from North Wales, the Witley Colliery had a large-diameter winding shaft with two cages running in it. The output of coal and fireclay was taken away by the Great Western Railway to the Corngreaves brickworks. The manager, J. C. Forrest, was later to sink and manage the Hilton Main Colliery near Featherstone.

After the Witley Colliery closed, the winding house remained on the site until the 1980s. As the major building on the colliery, the company made an effort to create an interesting structure of red brick with yellow firebrick details. The land was purchased by a national house builder and the winding house demolished.

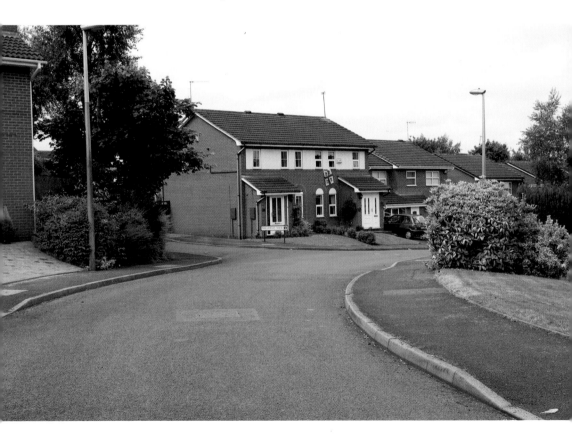

The Witley Colliery site in 2010 is now a housing estate with little evidence that colliery buildings once stood on the land.

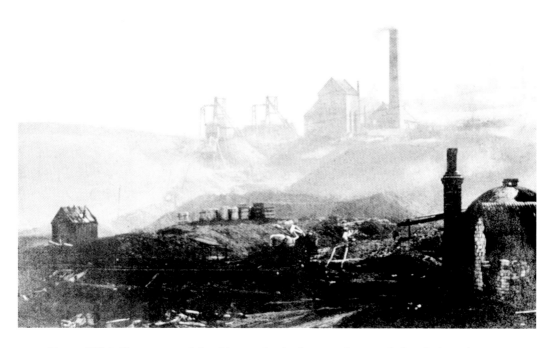

Homer Hill Colliery was sunk in 1865 to a depth of 130 yards to work the Thick Coal seam. It was the site of an explosion that killed three colliers in 1867. Thick Coal mining was to continue at the colliery until 1917, followed by the continued extraction of fireclay and coal from the Brooch seam until final closure in March 1928.

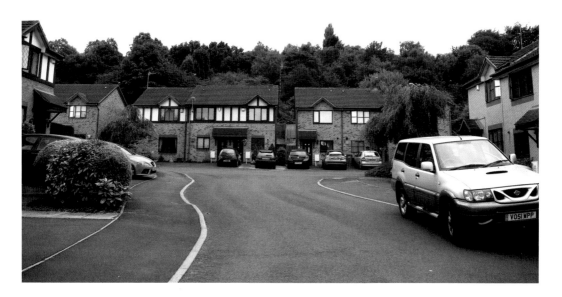

Homer Hill Colliery site in mid-2010. Much of the area is now unrecognisable with only the slope of the hillside to identify the site. The shafts were probably further up the hillside, under the trees.

OLDHILL

Serious mining was probably waiting for the construction of the Dudley No. 2 Canal, then for someone to prove the coal seams existed before risking their money. The 1834 sinking of the Haden Hill Colliery seems to have proved the spur to development. By the 1850s, collieries had been sunk alongside the canal and tramways from the pits down the hillside to canal loading basins dotted the landscape. Most of the collieries had closed by 1900, some of them to reopen under different names by new companies to work small areas of coal. After 1874, the Oldhill Drainage Company attempted to keep the remaining collieries clear of water, using plants at Fly and Windmill End Collieries. They went on to erect a modern pumping plant at Waterfall Lane in 1877 and drove long underground levels to bring the water to this pumping plant. In 1908, the money ran out and the pump was stopped, allowing the water to continue to flow into the Halesowen collieries.

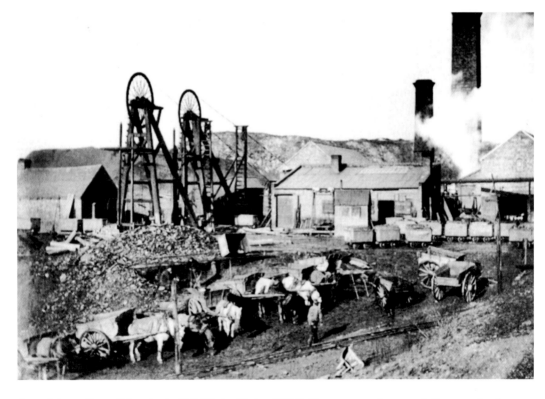

One of the earliest of the pits in Oldhill, the Haden Hill Colliery, was sunk around 1834 to a depth of 239 yards. Coal is heaped on the Pit Bank ready to be shovelled into the waiting coal carts for delivery round the local houses. Plenty of steam and smoke rise from the steam plant in the background in this scene from around 1880.

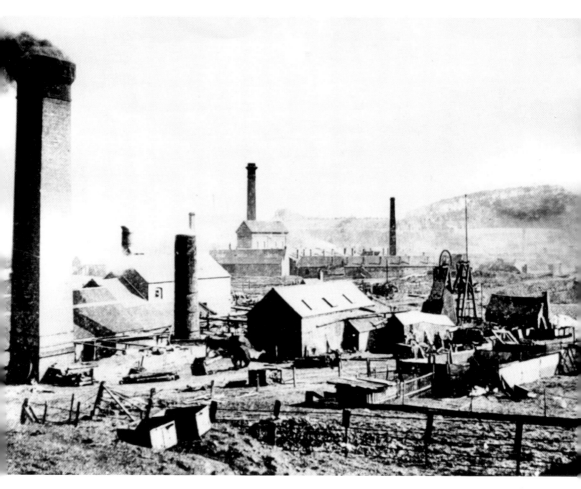

Haden Hill Colliery around 1890, with one of the head frames minus a pulley wheel. Around 1894, the colliery ceased coal winding leaving the steam engine to be connected to a generator to supply electric power to haulage motors underground and for lighting on the surface.

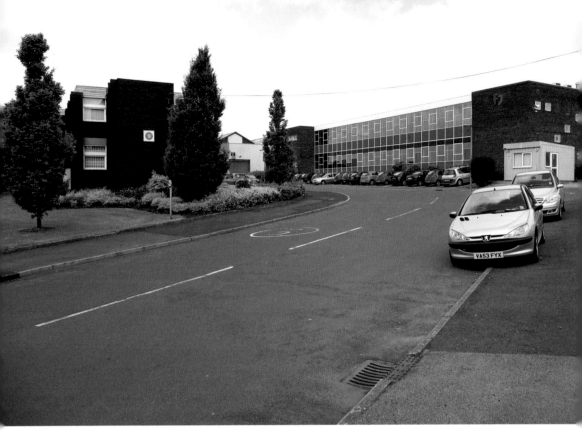

Haden Hill industrial estate on the same site in 2010. The mining buildings have all been replaced by modern concrete factory units while the colliery waste has been buried and grassed over. Only the higher level of the land and a widening of the nearby canal point to the site of the colliery.

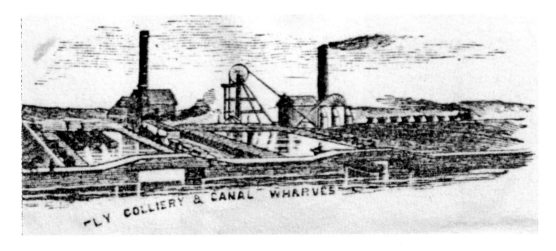

Sunk in the 1840s alongside the Dudley No. 2 canal, the Fly Colliery was one of the New British Iron Company's pits. It was also the terminus of the company's metre gauge railway and the outlet to the canal system for the company's iron goods. Operated by the Oldhill Furnace Company from 1897 to 1902, the colliery was eventually closed in 1926.

The site of the Fly Colliery, along with its canal basins and loading bunkers, has disappeared under a factory complex. This has left very little trace of the colliery until the ground is disturbed when the coal waste is found. On the side of the canal one of the bricked-up entrances to the basins can still be seen.

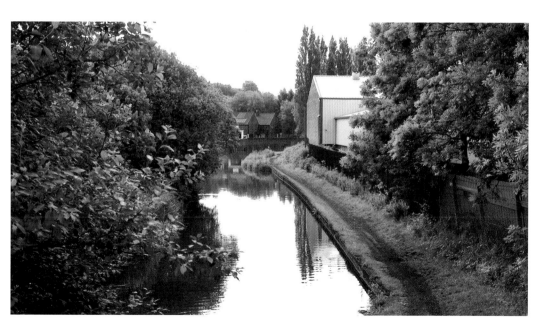

Fly Colliery. The indent in the canal side on the right is the site of the entry into the canal basins. During the nineteenth century, this was the only transport outlet for the Corngreaves Iron & Steel Works, being the only means of sending their goods across the world.

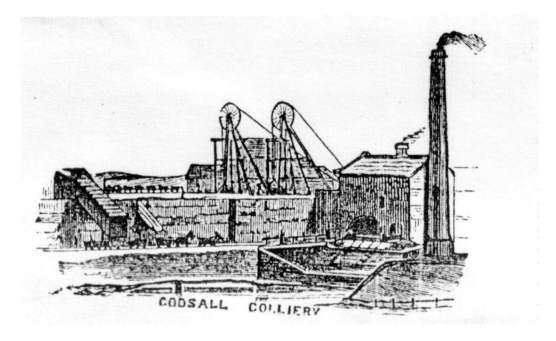

Working by 1849, the Codsall Colliery was another of the pits operated by the New British Iron Company. The shafts were sunk to a depth of 231 yards; the colliery produced ironstone as well as coal from its seams. It was closed in 1895 when the coal seams were said to be exhausted.

Codsall Colliery site is now a small nature reserve, an ideal place to walk the dog among the housing estates.

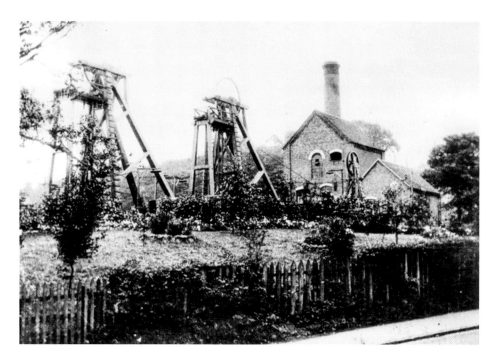

Haden Hill No. 2 Colliery was known as the 'Pretty Pit', as it was surrounded by roses and flowers to improve the view from the nearby Haden Hill Hall, the home of the landowning Haden family. Sunk in the 1860s, the colliery sent its coal in tubs down an incline to the Dudley No. 2 canal for shipment to the Oldhill Furnaces. It was closed in 1924.

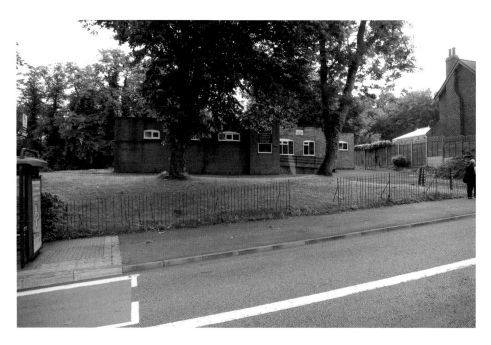

Haden Hill No. 2 Colliery site on Beauty Bank in 2010. The buildings have been replaced by a lodge of the Freemasons. The site is still surrounded by plants and trees.

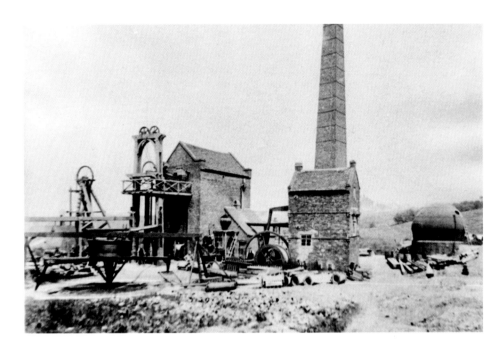

Above: Windmill End Colliery No. 3 Pit. A well-known view of the colliery, sunk around 1830, probably by the Earl of Dudley's Mining Department. Because of water problems the colliery from an early date had a Watt-type pumping engine. Re-cylindered during the 1860s, the engine was converted to the Cornish cycle and worked during the 1870s for the Oldhill Mines Drainage Company. Closed around 1925, the plant and buildings remained until the Newcomen winder on the right was brought by Henry Ford in 1928. This last Newcomen winder in the area was dismantled and shipped to the Henry Ford museum in Dearborn, Michigan, where it stands along with several other ancient steam engines.

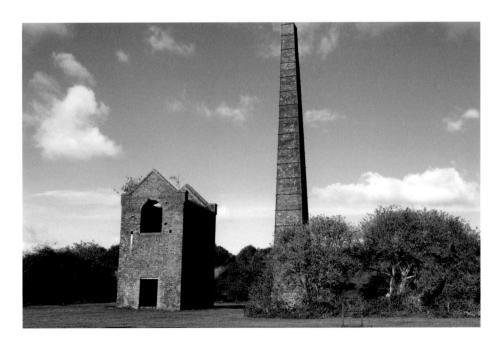

Opposite below: Windmill End Colliery. The same view taken in 2010 of the preserved pumping engine house and the square brick chimney. Restored during the 1980s, the building seems solid enough to survive most things in the Warrens Hall Country Park.

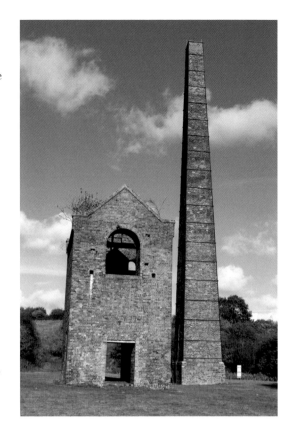

Right: Windmill End Colliery's brick-built, Watt-type, steam-pumping engine house of around 1830. Restored in the 1980s, it forms part of the Warrens Hall Country Park at Rowley Regis.

Below: Windmill End Colliery No. 3 pit with the canal and the Netherton Tunnel. Water from the mine was pumped into the canal and paid for at the rate of 4*d* per lock-full by the Canal Company.

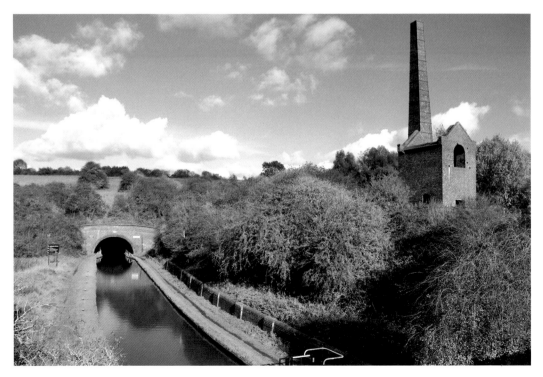

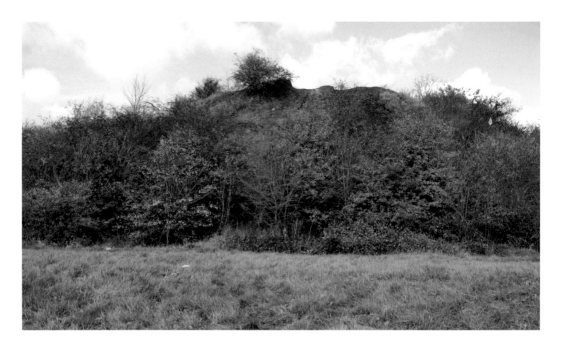

Warrens Hall Colliery. A large waste tip of coal shale forms a major feature of the Country Park.

Warrens Hall Colliery. A brick-built basin for loading canal barges on the Dudley No. 2 canal. Coal in tubs was lowered by ropes down inclines from high on the hillside to be loaded into barges at this basin. Once very common across the Black Country, many of these basins have been filled in and lost.

BIRMINGHAM

If coal exists under Birmingham it is down very deep and out of reach. However, a small mine with workings exists in the Birmingham University grounds as part of the former Mining Department. Constructed in 1904, the mine was used to train students for the industry and on occasions by the local Mines Rescue teams for training exercises. During the 1960s, part of the concrete-built underground workings was destroyed as part of the foundations of a multi-storey car park. Fortunately, the surface building and some workings still remain within the University.

Surface building of the practice mine in the grounds of Birmingham University. Within the building was a ventilating fan to demonstrate air conditions underground.

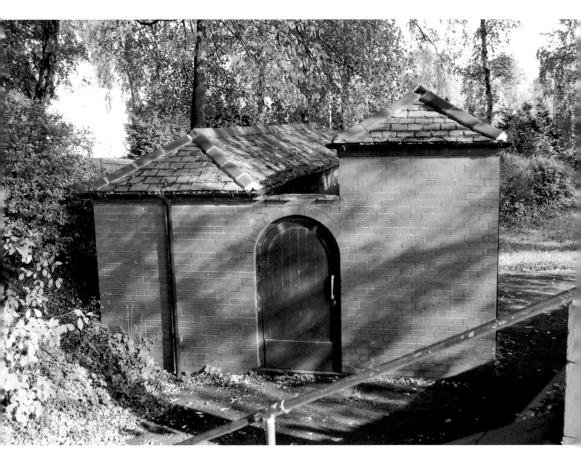

Entry to the practice mine with the ventilating fan chimney on the right. The workings are under the trees and grass in the background.

SMETHWICK

Sandwell Park Colliery was sunk to a depth of 418 yards in the period 1870 to April 1874. Being over the known boundary of the coalfield, the sinking of the first shaft was of great interest to the mining community. After a useful life, a second colliery known as the Jubilee was sunk into an isolated area of workable coal in Sandwell Valley. Taken over by the National Coal Board in 1947, this colliery worked until September 1960. The Sandwell Park sinking of 1870 with its successful outcome was quickly followed by the creation of two further companies to sink shafts in the hope of finding workable coal over the boundary. One, the Hamstead Company, went on to develop a colliery to rival Sandwell Park. The other – the Perry Colliery – sinking found only water, becoming a water supply plant for Birmingham Waterworks Company.

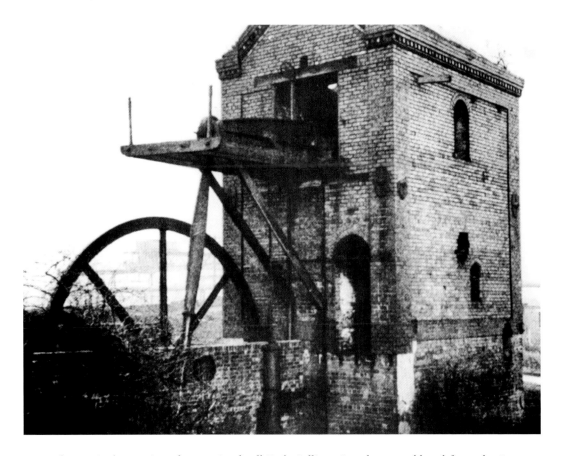

The original pumping plant at Sandwell Park Colliery. Bought second-hand from the Poynton Collieries, Cheshire, in 1870, this ancient steam engine was scrapped in the 1950s.

Built into the side of a railway cutting at Sandwell Park Colliery was a steam-driven underground haulage engine house. When, in the 1980s, the site of the colliery was used as a lorry park, it was decided to fill in the engine house before a lorry fell through the roof. Some brickwork and the path beside the railway still remain. (2010)

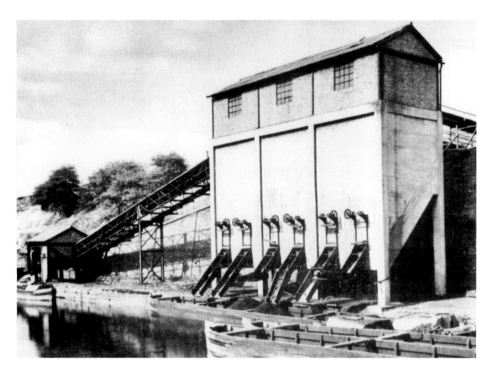

In the 1930s, Sandwell Park Colliery was taken over by the Warwickshire Coal Company and extensively modernised. To speed up the loading of canal barges, they erected a large, concrete loading bunker. Here is the loading bunker from a 1930s publicity article.

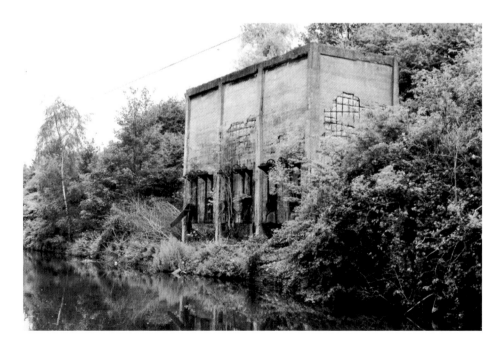

Sandwell Park Colliery. The same bunker as seen during the 1980s, much overgrown and derelict.

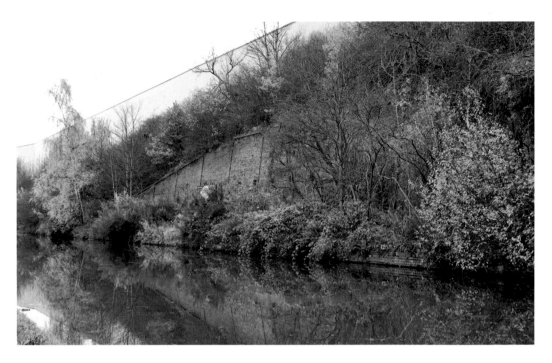

The Sandwell Park Colliery loading point was the subject of a renovation project in 2006 as part of the history of the area. An engineer's report discovered that the bunker was ready to fall into the canal so it was demolished. Here, the scene in 2010.

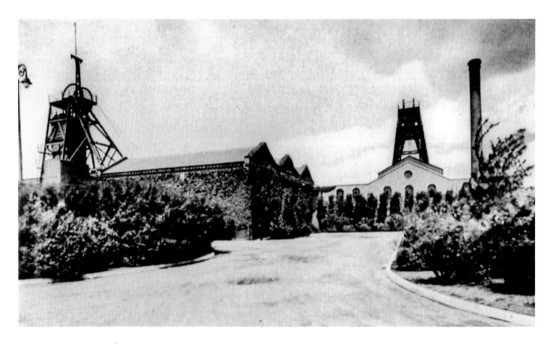

The Jubilee Colliery was sunk by 1908 near Swan Pool to work a detached area of coal not accessible from the Sandwell Park Colliery. Having extracted this limited royalty, the colliery closed on 16 September 1960.

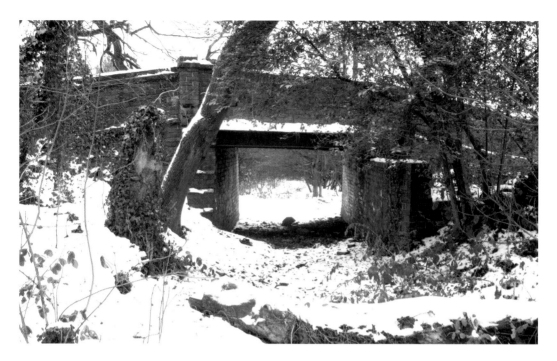

Coal from the Jubilee Colliery was taken in tubs by rope haulage back to Sandwell Park Colliery for screening and loading either into railway trucks or canal barges. Alongside the M5, the track of the haulage way can still be found.

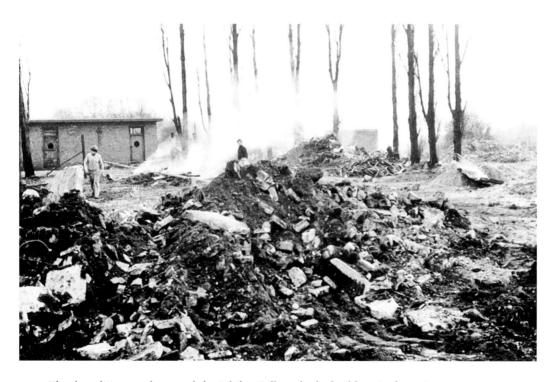

The demolition work around the Jubilee Colliery baths building in the 1960s.

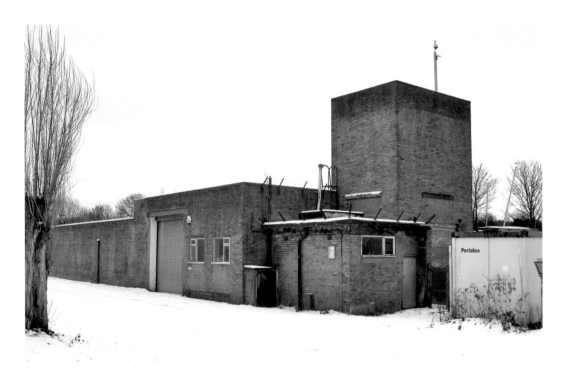

The Jubilee Colliery baths building was later taken over for the Sandwell Valley Sailing Club and still stands on the site. The existing car park at Swan Pool was part of the colliery yard.

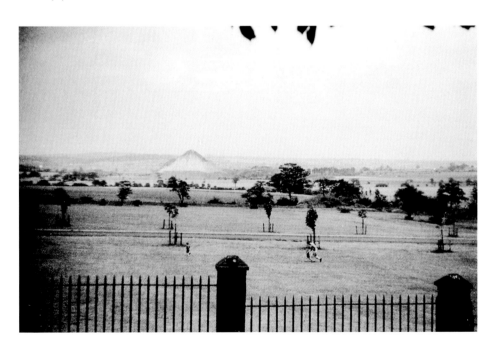

Sandwell Valley from Dartmouth Park, with the tip of the Jubilee Colliery in the background, during the 1950s.

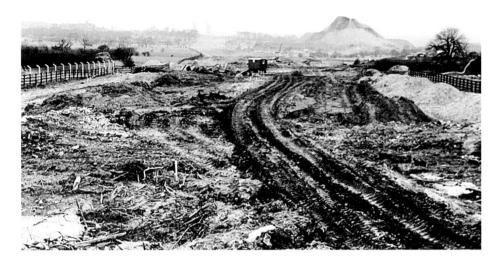

The construction of the M5 Motorway through Sandwell Valley. Much of the colliery tip was to be used as hardcore for the motorway.

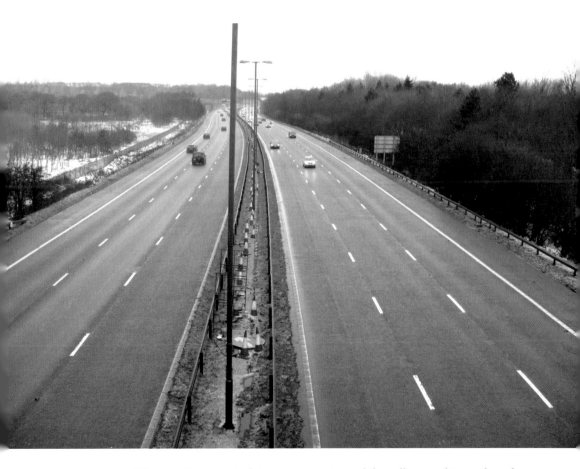

A similar view of the M5 Motorway in late 2010. Any signs of the colliery and its tip have been buried under grass and trees.

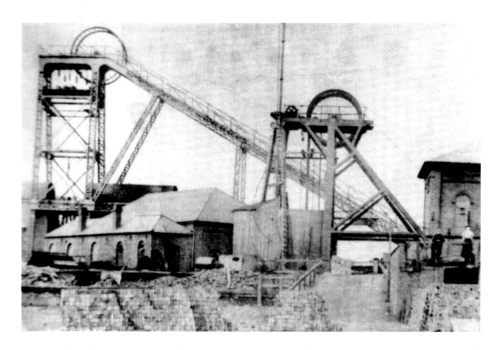

Hamstead Colliery main winding shaft under the tall steel head frame, with a small wooden head frame over the ventilating shaft, from around the 1890s.

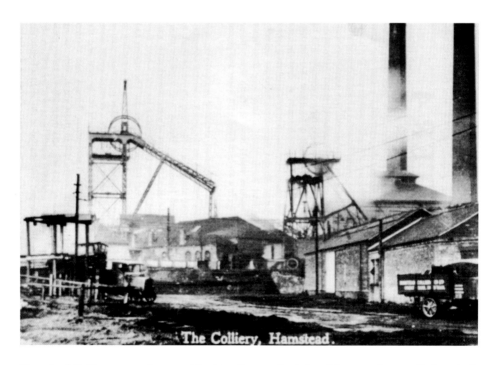

The Colliery, Hamstead.

Hamstead Colliery around 1920 with alterations to both head frames, the ventilation shaft frame having been rebuilt in steel. Two interesting lorries for coal deliveries stand in the pit yard. To encourage colliers to stay in the coal industry, Hamstead in the 1920s operated a number of lorries to transport people to the colliery.

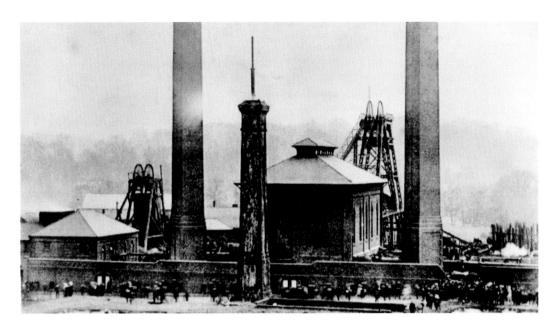

March 1908, an explosion at the Hamstead Colliery resulted in the deaths of 25 miners. Crowds of people wait for news of friends and relations. At an inquest on a collier killed in the workings at Hamstead, it was described as the most dangerous colliery in South Staffordshire.

Hamstead Colliery in 2011. Nothing remains of the colliery buildings; a search of old maps was required to find the site at the Tanhouse Centre and Library, Hamstead Road.

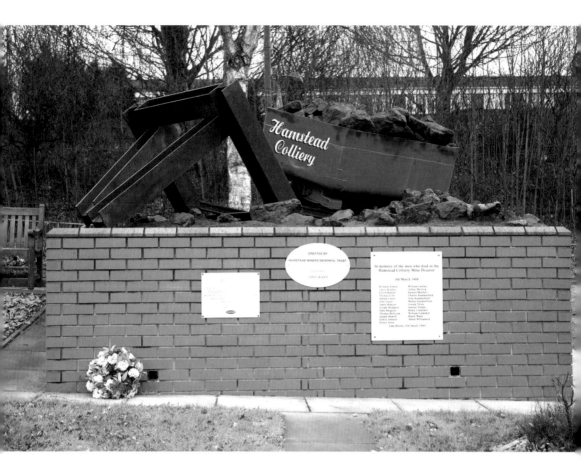

A memorial to those killed in the Hamstead Colliery disaster of 1908 at the junction of Hamstead Road.

HIMLEY

Coal mining in this area had existed for local use from medieval times. The use of steam engines and railways by the Earl of Dudley and John Bradley in the early nineteenth century helped the coal industry to develop. During the same period, the construction of ironworks provided greater demand for coal and ironstone found in the area. Most of the mines had closed by 1900 when the Earl of Dudley's mining department sank the Baggeridge Colliery over the supposed boundary of the coalfield to develop a major deep colliery.

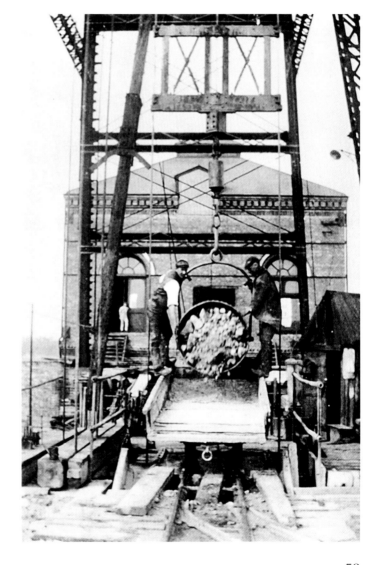

Sinking the production shaft at the Baggeridge Colliery around 1900. The two sinkers are busy tipping a bowk of rock from the shaft into a wagon ready for the journey to the tip.

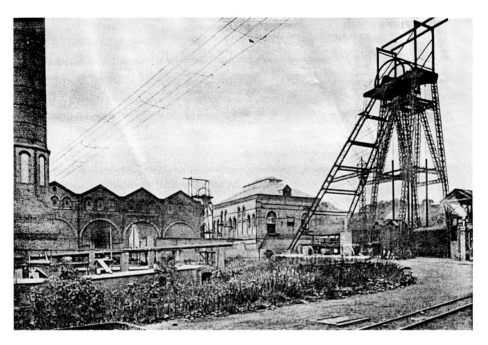

A busy scene at the Baggeridge Colliery, probably in the 1930s, showing the large head frame towering over the colliery buildings. The compound steam winder for this shaft was housed in the building in the centre.

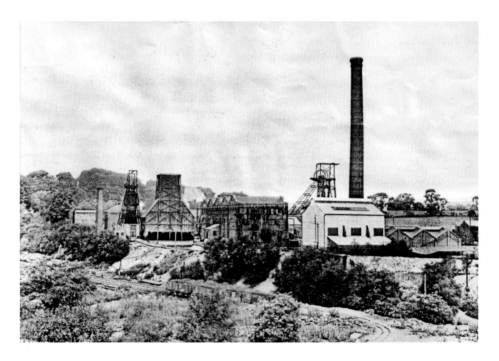

Baggeridge Colliery in the 1930s. The white building in the middle was a new boiler plant. The main winding shaft is to the right and the ventilating shaft is on the left behind the large wooden steam condensing tower.

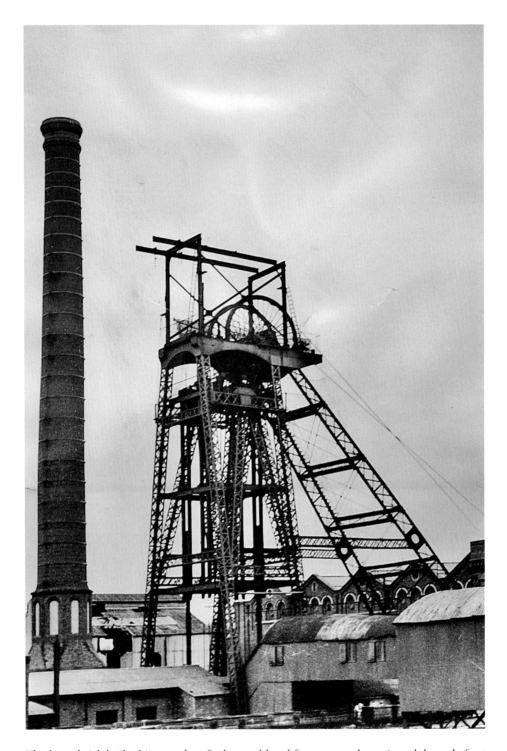

The huge brick-built chimney dwarfs the steel head frame over the 556-yard-deep shaft at Baggeridge Colliery. Under the National Coal Board from 1947 to closure in March 1968, this was the last colliery in the Black Country. In more recent years the site has become the Baggeridge Country Park.

Baggeridge Colliery buildings once stood here. This is now the Baggeridge Country Park in 2010.

The site of the huge waste tip of Baggeridge Colliery. Levelled and grassed over it makes a useful play area in the Baggeridge Country Park.

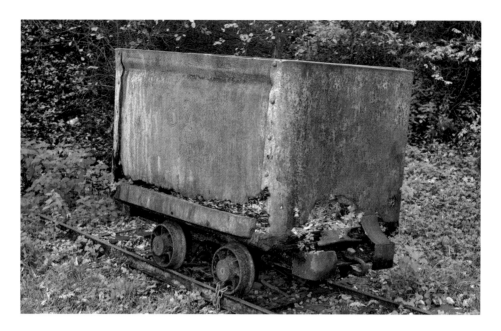

A colliery tub stands between two concrete blocks left from the steel head frame near the main shaft of the Baggeridge Colliery, now Baggeridge Country Park.

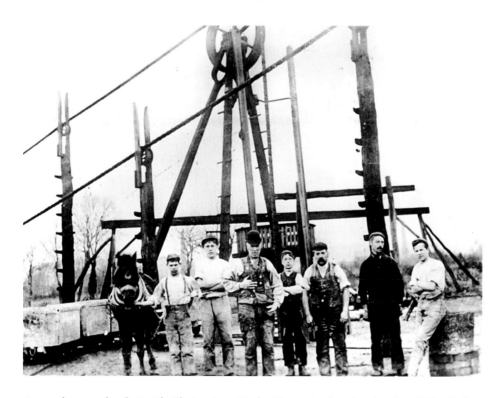

A superb example of a Rattle Chain pit at Himley No. 7 pit, showing the three-link winding chain over the pulley wheels. The upright posts are used to carry the weight of the chain over long distances. In the background is the horizontal drum showing the slats of a horse gin.

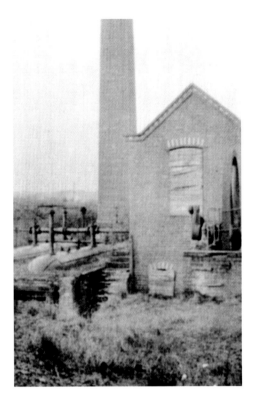

One of the Himley Collieries, with a steam winding engine peculiar to the Black Country. Developed by the Earl of Dudley's Mining Department, these engines were manufactured by the Earl's foundry near the Black Country Museum. The outside drums of a beam engine were operated by a horizontal steam engine in the brick engine house. This required a long connecting rod through the front wall of the building to drive the drums.

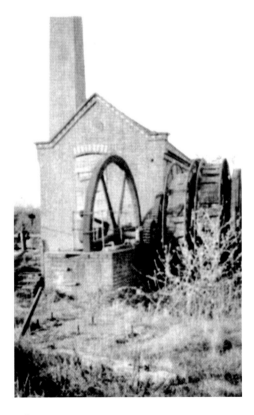

One of the Himley Collieries, derelict, showing this form of Black Country developed steam winding engine.

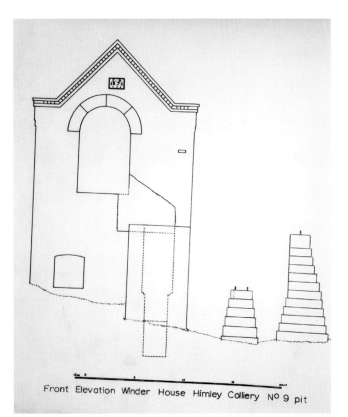

Front Elevation Winder House Himley Colliery Nº 9 pit

Himley No. 9 pit. During 1977, a series of measured drawings were made of this Black Country developed steam winder.

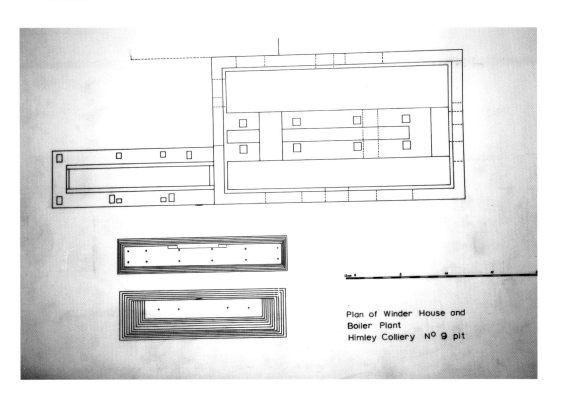

Plan of Winder House and
Boiler Plant
Himley Colliery Nº 9 pit

59

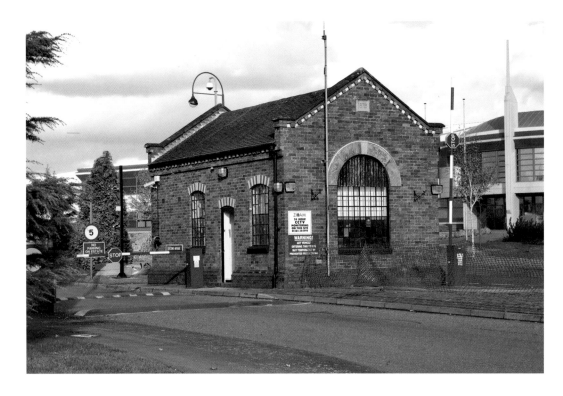

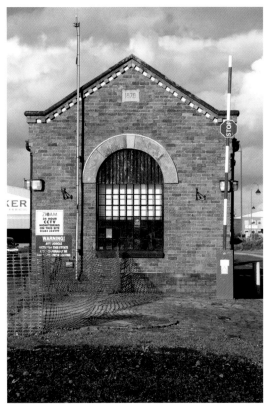

Above: The last example of this Black Country developed winder was at the Himley No. 9 Colliery, the building remained in existence until the 1970s when it was demolished for the sandstone arch and date stone (1876). Both the date stone and the arch are to be seen at the Pensnett Trading Estate, forming part of the security building.

Left: The reconstruction of the winding house from the Himley No. 9 Pit, now used as the security building at Pensnett Trading Estate. As part of the reconstruction a wooden head frame was erected in front of the building and a shaft traced out in brickwork. Unfortunately, the head frame rotted and was removed some years ago.

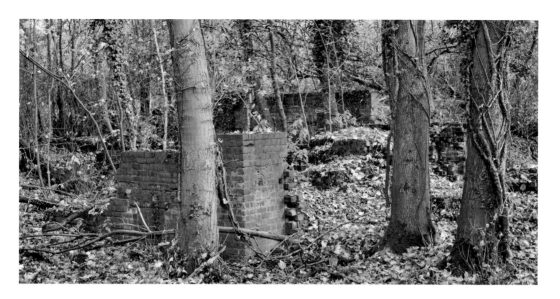

Himley No. 4A Pit. A small, late-nineteenth-century colliery in woodland south of Baggeridge Country Park. Brick-built remains of a twin-cylinder steam winder house and associated boiler plant.

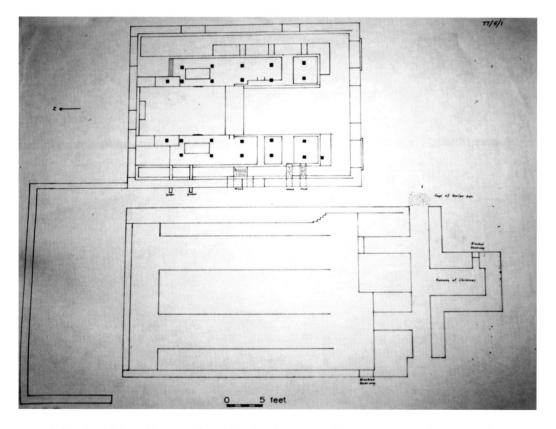

A drawing of the colliery winder and boiler plant at Himley No. 4A Pit; made in 1977 when more of the structures remained.

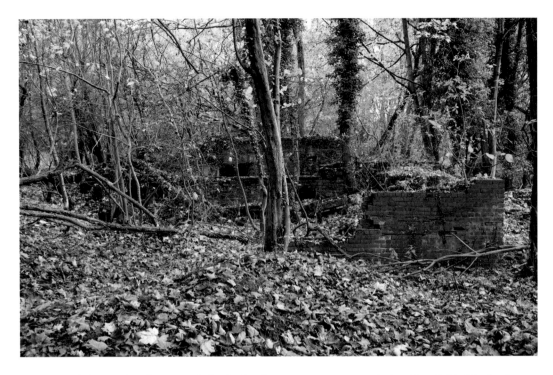

The front of the winding house and plinths for the steam engines at Himley No. 4A Pit. Much of the building has disappeared under the trees and undergrowth.

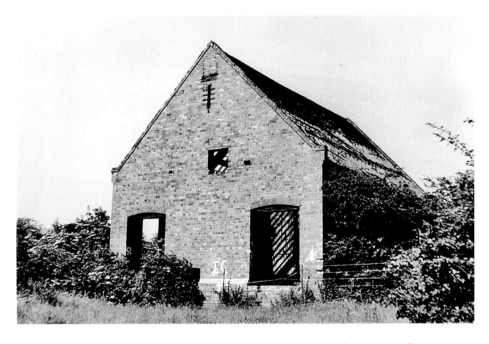

Bird's Leasow No. 3 Pit. The winding house for a late-nineteenth-century colliery as seen in 1977. A short length of plateway rail was found on the site. By 1977, the building was in the middle of a housing estate and being vandalised by the children.

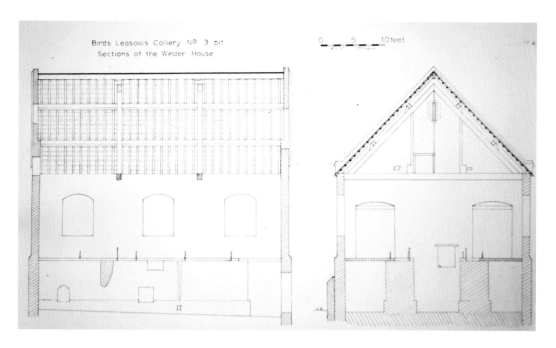

Bird's Leasow No. 2 Pit. Drawings of the winding house made in 1977. The site was cleared some years ago and replaced by houses.

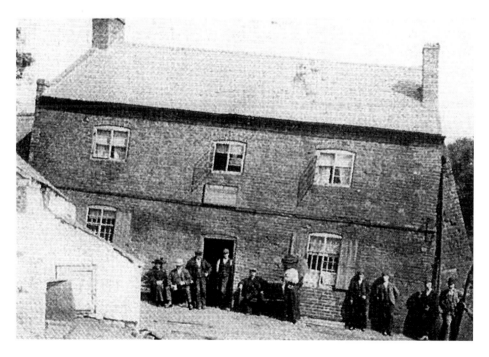

The effects of mining subsidence are well illustrated by the Crooked House Inn at Himley. Collieries in the Black Country were usually not liable for subsidence damage except under identified buildings. The canals and railways were warned of imminent mining operations and expected to purchase the minerals.

63

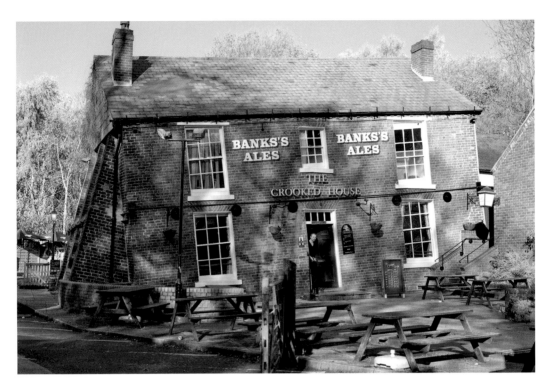

The Crooked House Inn on a sunny day in 2010. It is still in use as a public house.

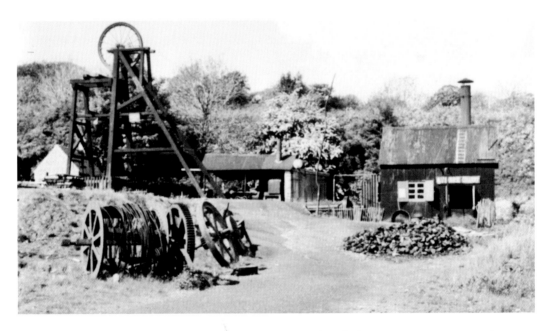

The re-sinking of the Coneygree Colliery No. 126 pit at the Black Country Museum. As this was once the site of a racecourse owned by the Earl of Dudley, this shaft has been renamed Racecourse Colliery No. 1 shaft. As is typical of a shaft sinking, a series of temporary buildings have been constructed.

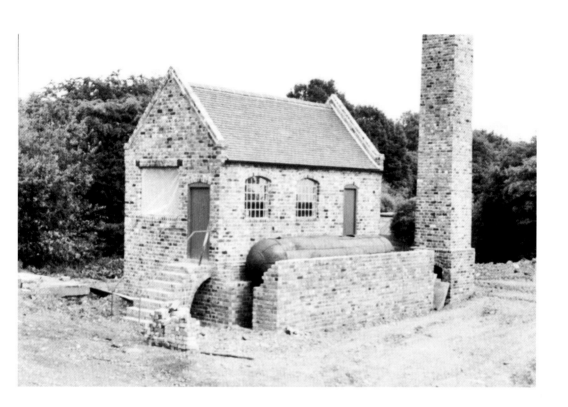

Above: Racecourse Colliery No. 1 pit. In the collections of the Black Country Museum was the single-cylinder horizontal steam winder from the Amblecote No. 12 Colliery. After an overhaul, this engine was available to wind from the shaft, so a reconstruction of the Amblecote Colliery winding house was built and the engine can be seen today.

Right: Racecourse Colliery No. 1 pit. With steam engines and a boiler available, the re-sinking of the shaft was undertaken using traditional methods by the Friends of the Black Country Museum Mining Group. Tipping a bowl of waste from the shaft sinking, the author in action as Banksman on the pit top.

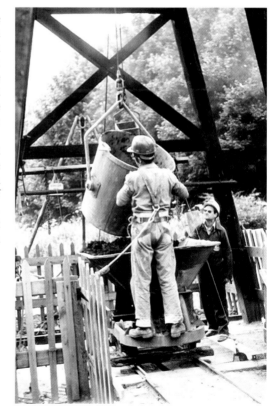

HILTON MAIN COLLIERY, FEATHERSTONE

This was sunk as the culmination of a series of coal workings going back to the seventeenth century. The first shaft was sunk in 1920 to a depth of 630 yards to cut the Eight Foot coal seam. Used at first as an air inlet (Downcast) shaft, it was designed to ventilate a series of workings of the Holly Bank Colliery. This was the first colliery in South Staffordshire to be all electric. Coal mining continued until the Holly Bank Colliery Co. liquidated in 1930 and was taken over by a company reconstituted, partly of directors of the old company plus some new men with new capital, to form the Hilton Main & Holly Bank Collieries Ltd in 1932. Three of the new directors were from the North-East, including C. A. Nelson of Newcastle, who was chairman and managing director of the Hartley Main Collieries Ltd in Northumberland. At the time the colliery was producing 508,380 tons of coal annually. The new company decided to improve the output and concentrate operations at Hilton. They sank a further shaft of 5 metres (16 feet) diameter in 1934 to complete the two-shaft layout of a colliery, followed by the gradual run down of the Holly Bank Collieries and transfer of colliers to Hilton. Output was increased to around 2,000 tons per day. It was taken over in 1947 by the National Coal Board; they saw a future for the colliery and invested large sums of money in a major modernisation of the surface buildings. Underground coal cutters were installed and four seams of coal worked. Due to difficult geological conditions the colliery closed on 31 January 1969.

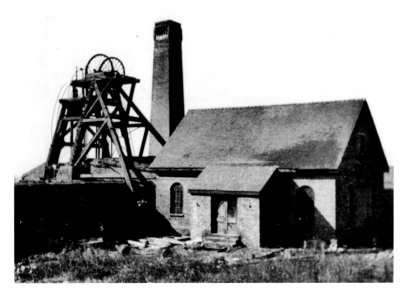

Holly Bank Colliery No. 15 Pit. The large wooden head frame with its two winding wheels for the two cages in the shaft. To the right is the brick winding house for the steam winder with the square chimney of the boiler plant in the background.

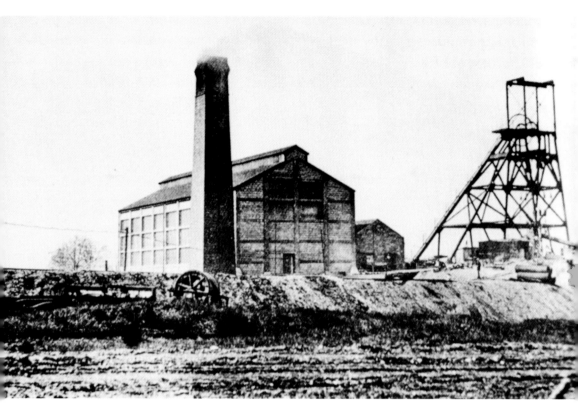

The sinking of the first shaft at Hilton Main Colliery in 1924 was done with steam engines, hence the square chimney for the boiler plant. Then the huge building behind the chimney was erected to house the electrical plant, air compressors and the massive electric winder. The steel head frame on the right was to be the permanent frame over the shaft of 630 yards depth.

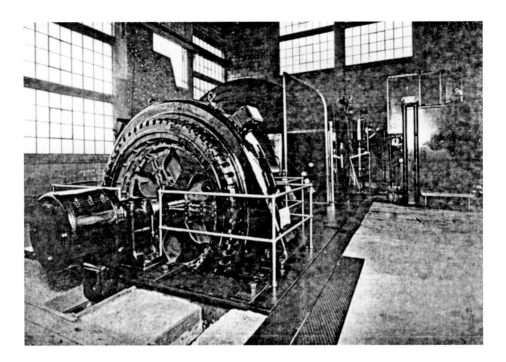

Located inside the Main Power House at Hilton Main Colliery was the huge electric winder for the 630-yard-deep shaft. The winder was said to be one of the largest in the country when manufactured in 1924.

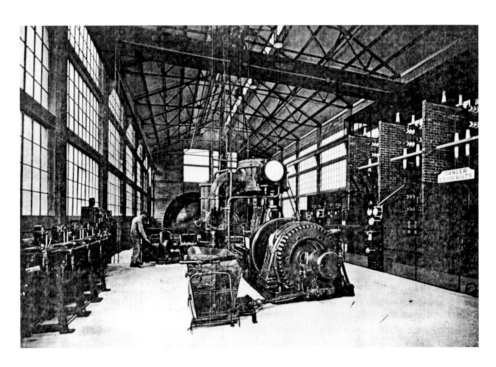

Hilton Main Colliery, inside the Main Power House with air compressors in the foreground, electrical equipment to the right and a maintenance crane in the roof.

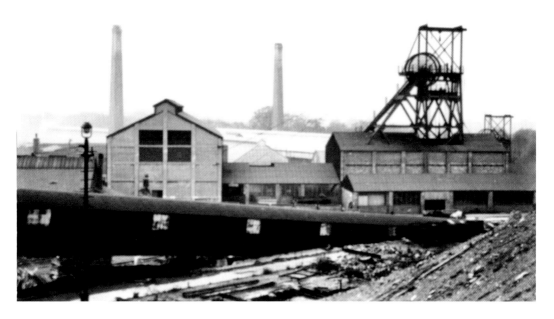

Hilton Main Colliery in NCB days with two steel head frames over the shafts. The buildings surround the Downcast (air inlet) shaft top. Here the coal tubs arrived within the building on the right at the base of the steel head frame. The tubs were then taken to be tipped onto the conveyor system going from left to right in the foreground.

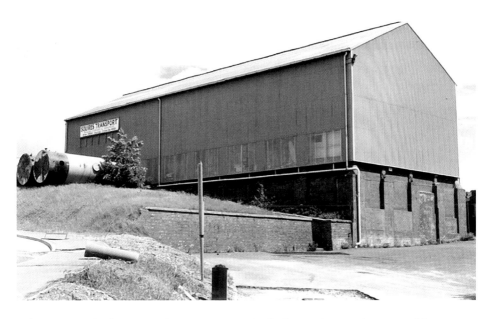

Hilton Main. The former Main Power House in the late 1980s was being used by Squires Transport as a distribution depot. Later it was left derelict when the lorry park on the site was in use.

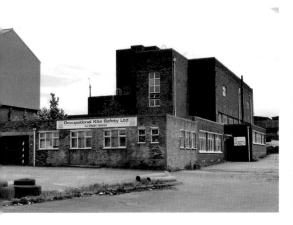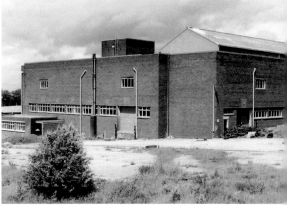

Above left: Hilton Main. Huge National Coal Board built baths house in the late 1980s. The building was later reduced to a single storey and then demolished.

Above right: Hilton Main. The huge brick-built baths house and welfare building constructed by the National Coal Board, as seen in 1994, since demolished.

Hilton Main site in 2010. The remaining colliery buildings were demolished and replaced by large warehouse units. To date, only two have been completed and they stand on the site of the pit top.

THE CANNOCK CHASE COALFIELD

The Cannock Chase Coalfield forms the northern section of the South Staffordshire Coalfield. It stretches from the Bentley fault in the vicinity of Walsall to Wednesfield, north of Rugeley. The coalfield is nearly 12 miles long north to south and nearly 10 miles wide. On the east side, the Eastern Boundary fault forms the end of the coal measures. To the west, the Bushbury fault forms the termination of the coal measures. It has been suggested that the Thick Coal seam of South Staffordshire, as it travels north separates into a number of thinner seams to form most of the seams of the Cannock Chase coalfield. Up to 16 seams of varying thickness occur in this coalfield, the best being about 10 feet thick.

The earliest coal mining appears to have been in the Beaudesert area where several seams come to the surface. Extensive remains of these early workings can still be found in the area. Brownhills Common was another area of early mining, most of which has now been landscaped. Deeper mining had to wait for the development of the steam engine from 1712 onwards to become a reality.

The sinking of two shafts at Walsall Wood Colliery commenced during 1875, while the company was registered on 15 November 1875. Sinking to the Deep Coal seam was completed at a depth of 576 yards in 1876 and coal production commenced. The colliery was to operate one of the pioneer electric coal cutting machines and to be early in the use of steel props underground. Yet it was to be the last colliery in the country to use furnace ventilation until replaced in 1959.

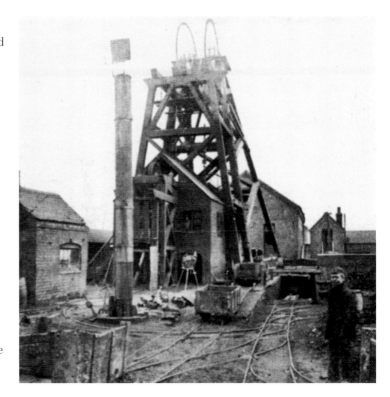

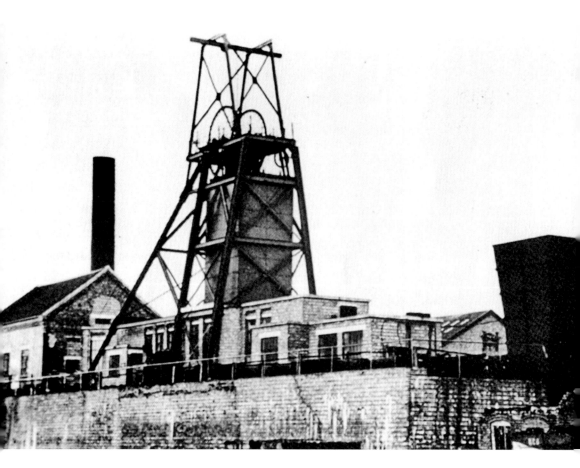

Walsall Wood Colliery after extensive modernisation by the National Coal Board in the 1950s. The steam winder had been replaced by an electric winder and the boiler plant demolished. Over the shaft a steel head frame had been erected and the underground furnace replaced by the electric ventilating fan on the right. After all this expenditure, the colliery was closed on 30 October 1964 because of the exhaustion of the coal seams.

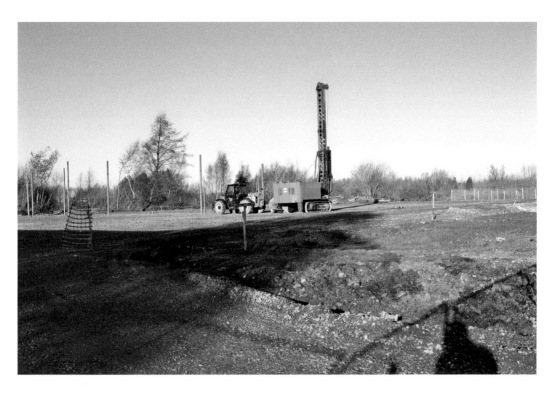

Walsall Wood, 2011. The shaft top area is being drilled, probably to check or improve the shaft filling. This would have been the site of the Upcast or ventilating shaft.

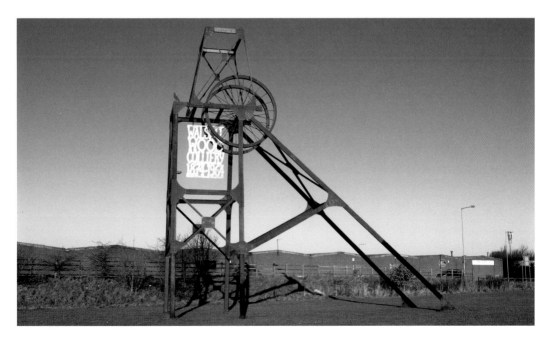

Walsall Wood, 2011. On the nearby playing fields a light steel head frame has been erected to remind people of their industrial heritage.

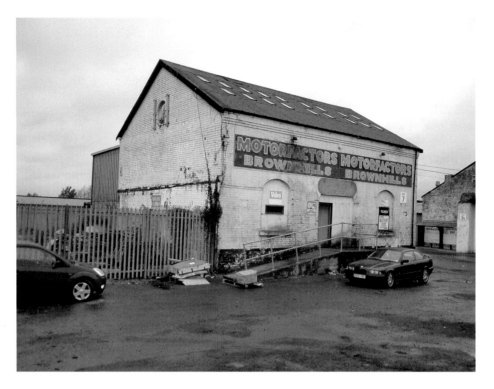

Walsall Wood's former steam winding house is now part of an industrial estate in Lindon Road. Now derelict, the building was constructed in 1874 to house the main winding engine of the colliery.

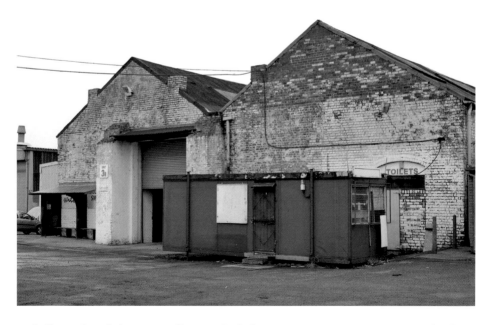

Walsall Wood workshops are still in use for light engineering purposes. One is said to have been the locomotive shed in National Coal Board days.

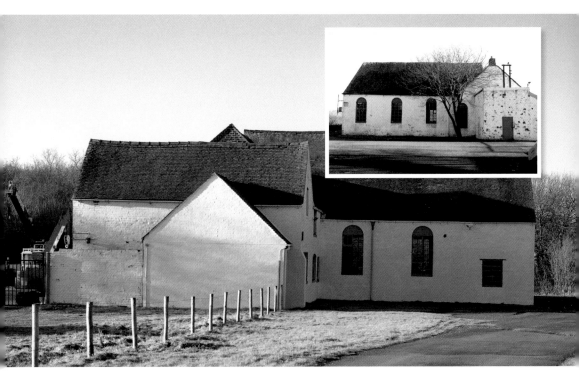

Brownhills Colliery Cathedral Pit. Sunk about 1840 by W. Harrison & Co., the colliery closed in 1910 after a productive life. The buildings were taken over for engineering purposes and are still in use.

Inset: Brownhills Colliery, Cathedral Pit. The 1840s colliery buildings are still in use and therefore preserved to be seen today.

Brownhills Colliery, Cathedral Pit. Among the trees stands a waste tip from this 1840s colliery. The tip is now used by the off-road cycling fraternity.

Wyrley Grove Colliery, sunk in 1852/53 by W. Harrison & Co. to a depth of 129 yards. The colliery had a productive life sending much coal away by either railway or canal. Closure because mining had become uneconomic came in November 1950. The surface plant still remained to supply washing facilities for the Wyrley No. 3 Colliery until 1963.

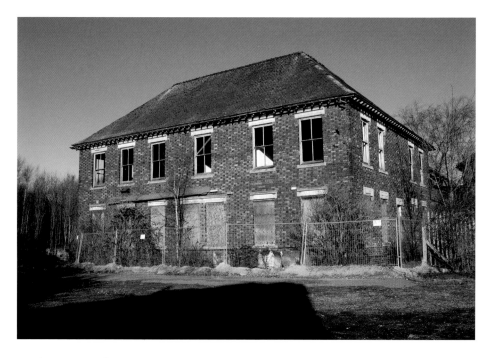

Wyrley Grove Colliery. W. Harrison & Company's headquarters building was later used by the National Coal Board as their wages offices. It is now derelict and collapsing.

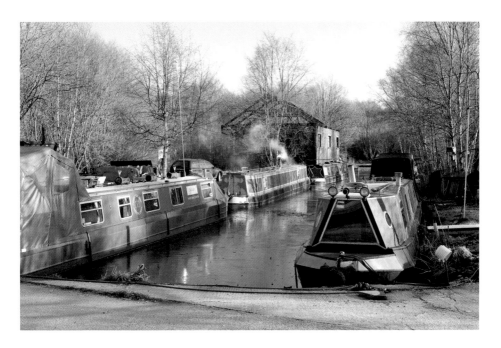

Wyrley Grove Colliery. Two large basins on the Cannock Extension Canal, once busy with the loading of coal into narrow boats on the canal, are now quiet places still used to store boats.

Brownhill No. 3 Colliery, sunk by William Harrison & Company in 1896. Tubs of coal were taken by narrow-gauge tramroad to the Grove Colliery for washing before the coal was loaded into either barges on the canal or railway trucks. Output in 1947 was 324,921 tons from 897 men. After nationalisation the colliery was renamed Wyrley No. 3 Colliery. The colliery closed during June 1967.

Wyrley No. 3. After closure in 1967 the buildings found further use as workshops for light engineering and storage. When visited in 1983 the site was in a reasonable state.

Wyrley No. 3. A recent (2011) visit found most of the buildings either derelict or falling down. Many appeared to have been vandalised.

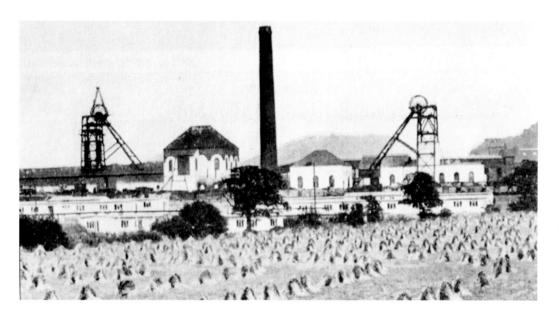

Mid Cannock Colliery, sunk from 1873–75 to work the Deep and Shallow coal seams of Cannock Chase. By 1880, the colliery had closed and the equipment was sold at auction on 15 December 1881 at the Queens Hotel in Birmingham. The shafts were filled and the site abandoned until reopened and the shafts cleared out in 1913. The new owners were William Harrison & Company who operated the pit until taken over by the National Coal Board in 1947. The output in 1947 was 217,258 tons from 845 men.

Mid Cannock, 2011. The gates into the colliery once had N. C. B. in large green painted steel letters on them. Unfortunately, these have been replaced by the nondescript gates shown.

Mid Cannock, 2011. Within the gates, a single-storey building remains from the National Coal Board days. Most of the site has now been cleared and levelled for the storage of hundreds of sea containers by Pentalver.

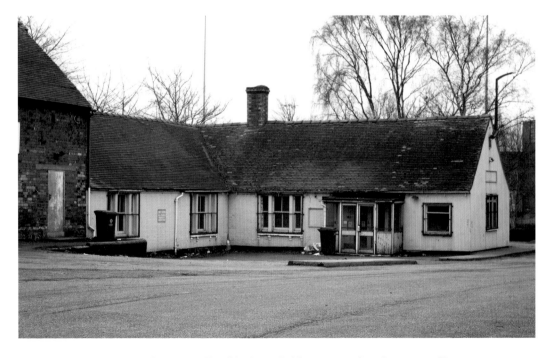

Mid Cannock, 2011. A single-storey office block, probably once used as the Time Office, remains in reasonable condition. Until recently it was used by a construction company for their offices.

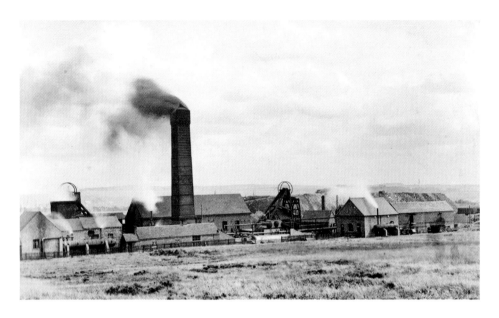

West Cannock No. 1 Colliery. Warm air rises from the ventilating shaft on the left while steam rises from the exhausts of two engine houses. The shafts were sunk between 1871 and 1876, to a depth of 346 yards to the Deep Coal seam. The colliery was taken over by the National Coal Board in 1947 and closed in 1958.

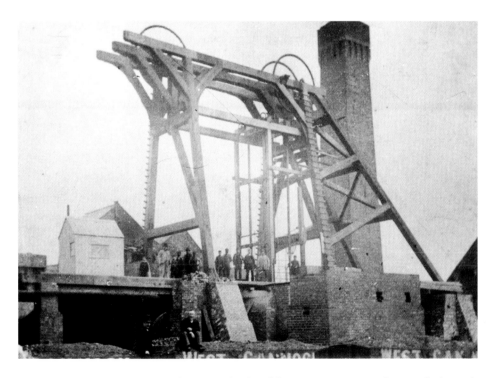

West Cannock No. 3 Colliery. A huge wooden head frame towering over the two shafts sunk to the Deep Coal seam at a depth of 302 yards, 1871 to 1874. By 1900, the colliery employed around 274 men, this number rising to 324 by 1945. The colliery closed in 1949.

WEST CANNOCK NO. 5 COLLIERY

West Cannock No. 5 Colliery was sunk in 1914 to 1917 into a heavily faulted area. The colliery was so beset by geological problems that it was 1922 before coal was produced. Taken over by the National Coal Board in 1947 the colliery was extensively modernised in the 1950s but lost large areas of coal reserves because of geological problems. Closure came on 17 December 1982.

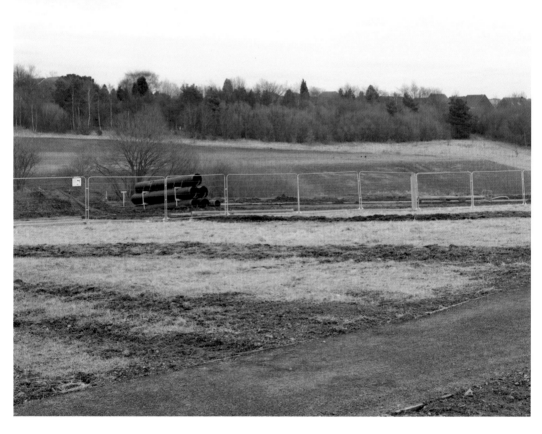

West Cannock Colliery, 2011. Nos 1 and 3 Collieries were located in the Pye Green Valley, the subject of a major landscaping project in recent years. This has resulted in the complete elimination of any remains.

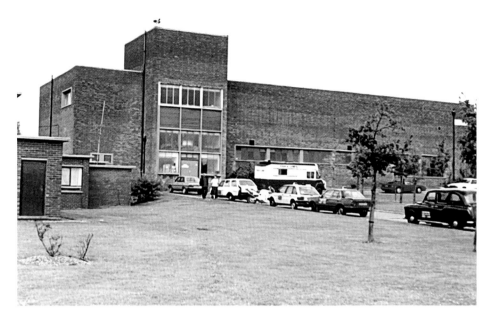

West Cannock No. 5's former bath house, converted to light engineering as part of the West Cannock trading estate.

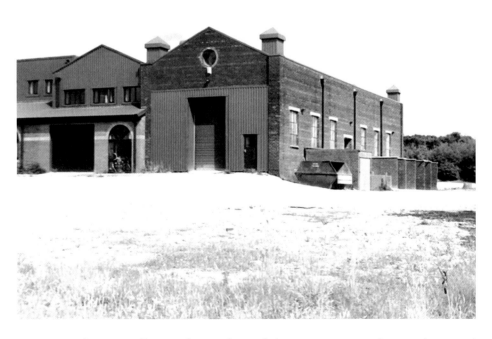

West Cannock No. 5. Following closure, the workshops were converted to warehouse and light industry as part of a trading estate.

EAST CANNOCK COLLIERY

Two shafts were sunk in 1871 with the first coal produced in 1874. The company went into liquidation in 1880 while the colliery was purchased by a new company in October 1880. Having cost about £150,000 to create the concern, it was sold for £20,000. The East Cannock Colliery Company operated the colliery until nationalised in 1947 when the output was 211,018 tons of coal. It was finally closed in May 1957 when the colliery was said to be exhausted.

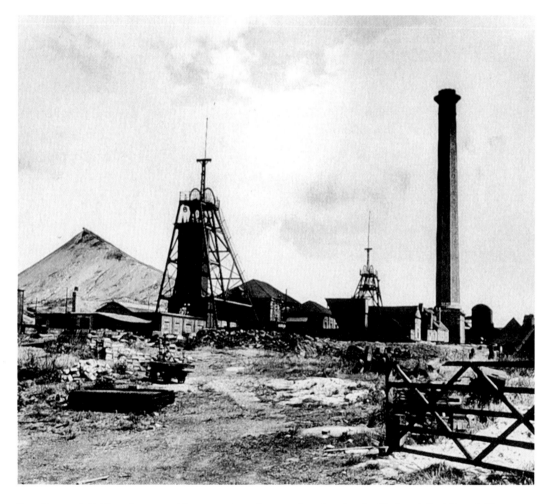

East Cannock Colliery in 1957 with many alterations undertaken by the National Coal Board. The timber head frames have been replaced by steel frames with tall derricks on top for lifting the pulley wheels.

East Cannock 2011. Most of the site has disappeared under housing while a small area was left to become a nature reserve.

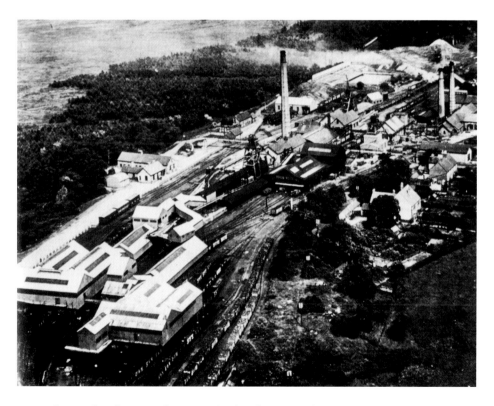

Cannock Wood Colliery, sunk in 1864/65 by the Cannock & Rugeley Colliery Company, this pit was to be one of the success stories of the Cannock Chase coal field. By the 1870s, this coal mining complex was capable of producing 15,000 tons of coal per week. Cannock Wood was to eventually close in 1973.

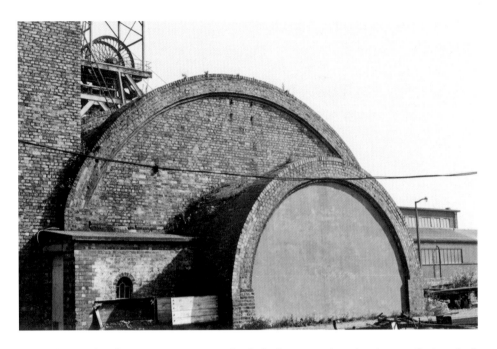

Cannock Wood Colliery. During 1874, a third shaft was sunk to be the ventilation shaft for the mine and a 40-foot-diameter Guibal ventilating fan was erected to replace the old furnace method of ventilating the mine workings. Reduced to a standby unit when electric fans were installed, the Guibal was still complete with its steam engine when the colliery closed in 1973. Manufactured by Black Hawthorn of Gateshead, the steam engine was dismantled by a team from Beamish Open Air Museum and, now fully restored, can be seen at this North of England Museum. It is planned to be used to drive their colliery fan.

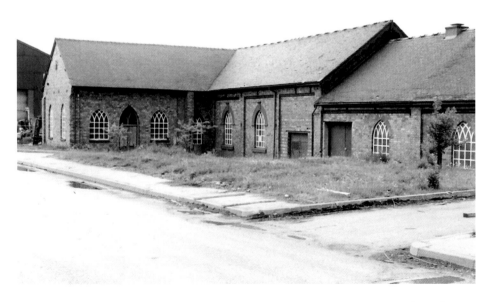

Cannock Wood today. The shaft top and screens area has become storage or had warehouses built as part of the Cannock Wood Industrial estate. One of the best groups of workshops of the 1860s period has become a joinery works.

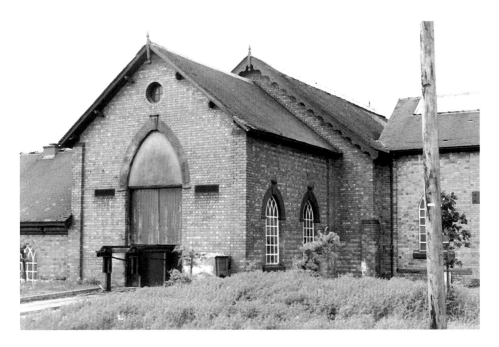

Cannock Wood. A building of the 1860s is now part of a joinery works.

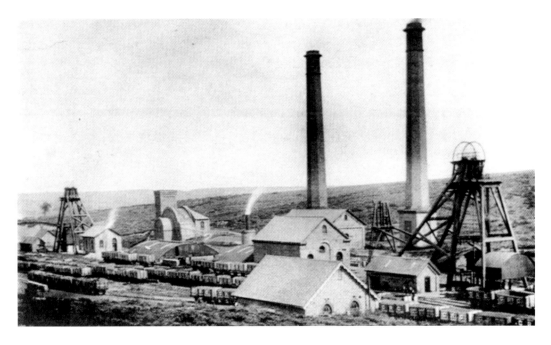

Also sunk by the Cannock & Rugeley Colliery Company, the Valley Colliery was sunk to work the Shallow and Deep coal seams in 1874/75. By 1889, all coal mined by the Valley's colliers was raised at Cannock Wood shafts to be screened. During 1922 the wooden head frames were found to be rotten and new steel frames were erected. Under the National Coal Board, the Valley developed into the training school for the local collieries and since closure has become the Museum of Cannock Chase.

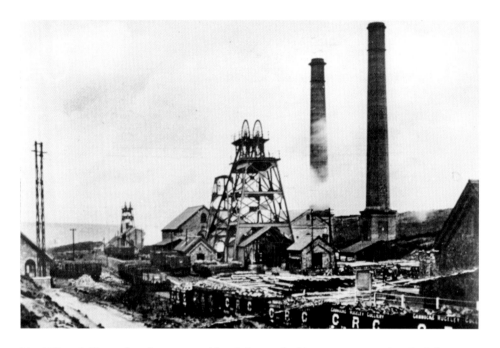

The Valley Colliery after the new steel head frames had been constructed and while steam was still much in evidence to operate the colliery.

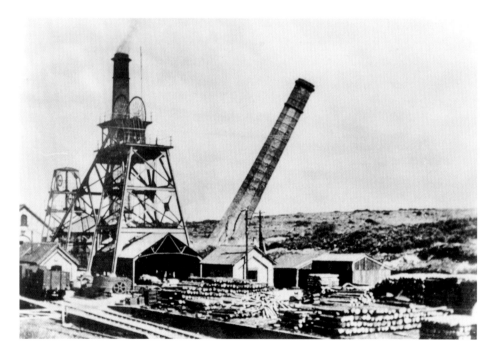

Under the National Coal Board, the steam-driven plants were converted to be operated by electricity with new winders and machinery. The old boilers and chimneys were cleared away to provide space for modern buildings and a new plant. The felling of a chimney was always an occasion for a photograph – Valley Colliery, probably in the 1950s.

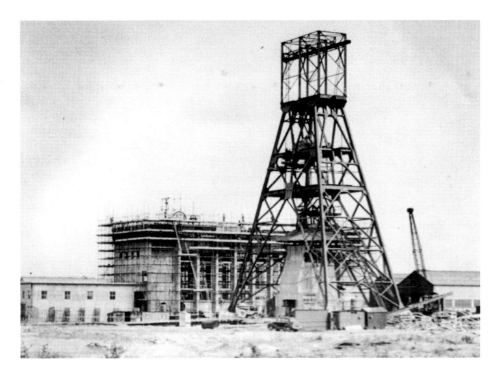

The first all-new colliery to be planned by the National Coal Board was sunk in the period 1954 to 1960, near to Rugeley. From the beginning it was intended that the projected output of over one million tons of coal annually should go into the nearby Trent Valley power station to produce electricity for the Midlands. Working until December 1990, the colliery was always at the top of the output tables.

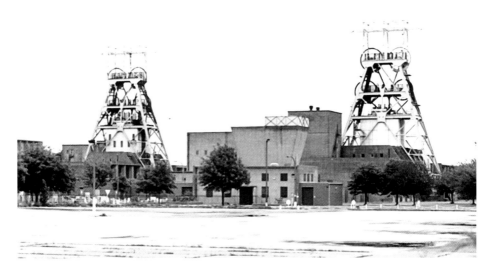

Lea Hall Colliery in April 1991 prior to the demolition of the buildings. The large-diameter shafts made it possible to operate four skips in each shaft if required. Only one shaft was so fitted.

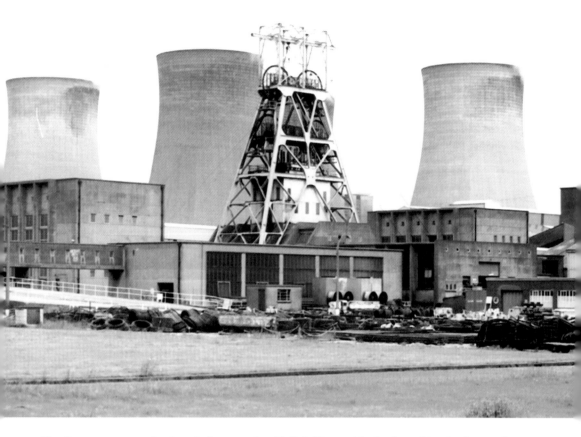

The Downcast or production shaft top at Lea Hall Colliery with the four skips in the one large diameter shaft and the concrete buildings of the colliery. In the background are the huge cooling towers of the power station.

LITTLETON COLLIERY

Commenced in 1873 by the Cannock & Huntingdon Colliery Company, the shaft sinking was expected to have huge inflows of water to deal with. To combat the water, the Kind Chauldron method of boring was brought over from Belgium to sink the two shafts. When the two shafts had been bored to a solid rock stratum, water-tight iron linings were to be put into the shafts. Then, once dry, the sinking would have been continued by hand methods. By 1880, at a depth of 438 feet, water broke into a shaft and flooded it almost to the surface. The other shaft soon met with a similar fate. Following attempts to raise additional capital to continue work, the company was wound up in 1884. Recommenced by Lord Hatherton as the landowner in 1897, the No. 2 shaft was sunk to a depth of 1,644 feet on 17 February 1899. Attempts to recover the No. 1 shaft were abandoned on 3 May 1900 as the shaft filled with water. A new shaft was sunk to a depth of 1,662 feet on 22 November 1902 after dealing with huge quantities of water. The old No. 1 shaft was later used as a source of water for the colliery and surrounding area. Trading as the Littleton Collieries Limited, the colliery was to be one of the most successful on Cannock Chase, lasting into National Coal Board days before closure as the last working colliery on the Cannock Chase coalfield in 1994.

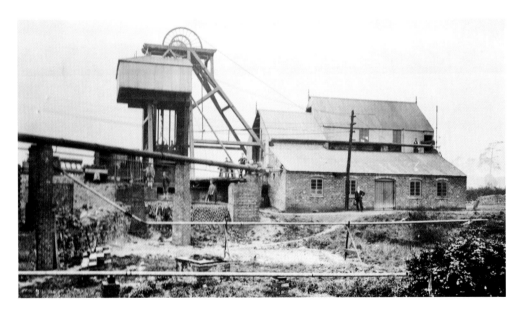

The sinking of the shafts at Littleton Colliery in 1898. The temporary buildings housed the steam plant to raise the 'Bowk' or bucket for waste rock in the shaft. Steam was also supplied to the small building in the head frame to operate small engine for lifting the pumps in the shaft. It required three steam pumps capable of lifting 1,000 gallons per minute to remove the huge inflow of water from the shaft.

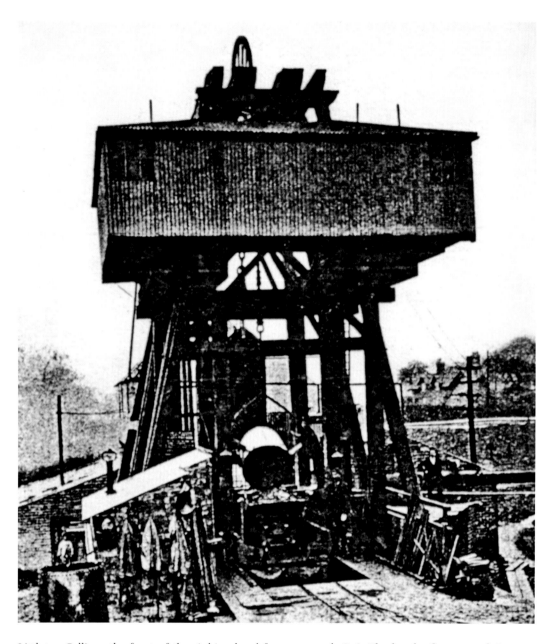

Littleton Colliery, the front of the sinking head frame around 1898. The bowk of waste rock is being tipped into a wagon on the shaft top. The oilskins hanging on the hovel wall on the left suggest the wet conditions underground.

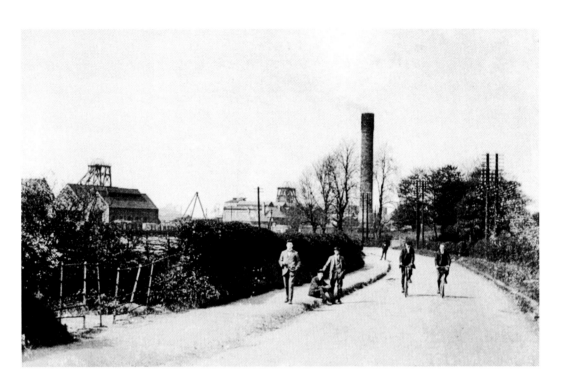

Above: Littleton Colliery: a peaceful
scene around 1920 with the head
frames in the background. It suggests
a Sunday view with the cyclists and
walkers enjoying the good weather. The
trees give a country appearance much
in contrast with the scene today.

Right: The tall steel head frame and
airlock of the Upcast shaft at Littleton
Colliery with the 'Evasse' chimney of
the mine ventilating fan on the right.
View of the colliery in 1994 after
closure and before demolition.

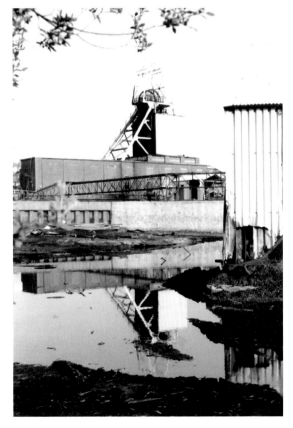

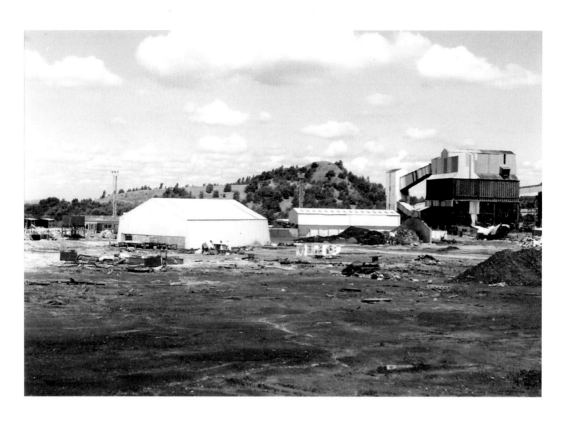

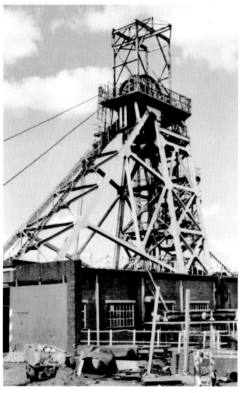

Above: The coal screening and washery plant being demolished during 1994.

Left: The Downcast or production shaft and steel head frame at Littleton Colliery in 1994. The shaft had been equipped with skips to speed the output to make the magic figure of one million tonnes per year possible. The colliery was to achieve this figure regularly in its later years.

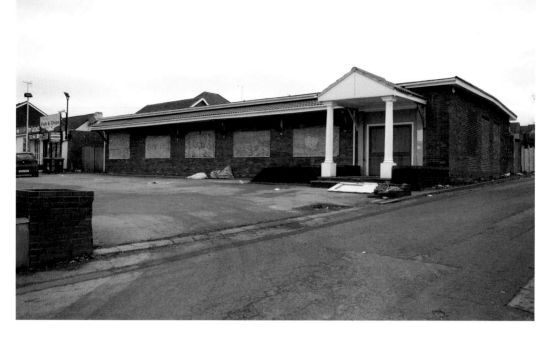

In 2011, the only remaining building from the colliery is the ground floor of the baths and welfare building. Formerly two storeys high, it is now derelict and boarded up.

Littleton 2011. While most of the site has now been redeveloped for housing, the colliery is remembered in the name of the medical centre.

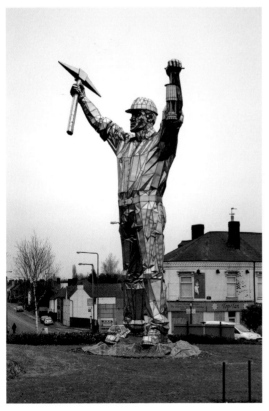

Above: Littleton Colliery, 2011. Very few of the former colliery tips of waste remain to be seen in any part of the country, let alone South Staffordshire. One in another part of the country has been scheduled as a landscape feature. Fortunately, this waste tip is still a notable part of the Littleton scenery.

Left: On the roundabout at High Street, Brownhills, stands this figure of a miner as a monument to the once-important coal mining industry of Cannock Chase. The industry itself is now only part of the history of the area. The end of an era.